PEGASUS
Library

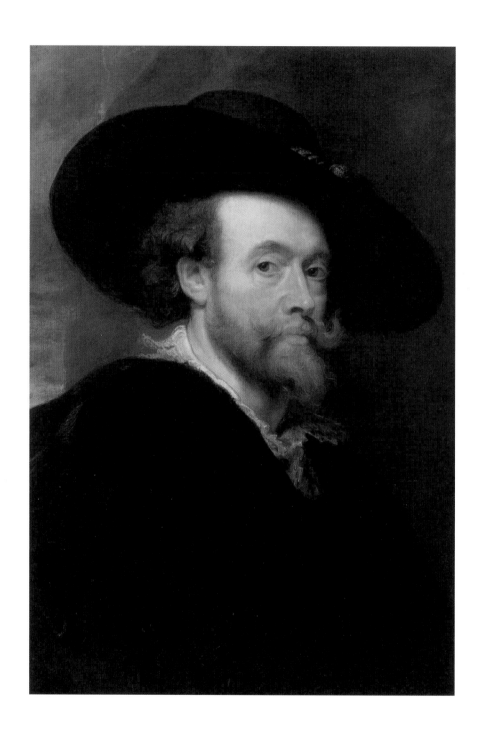

Dagmar Feghelm
Markus Kersting

Rubens
and his Women

Prestel

Munich · Berlin · London · New York

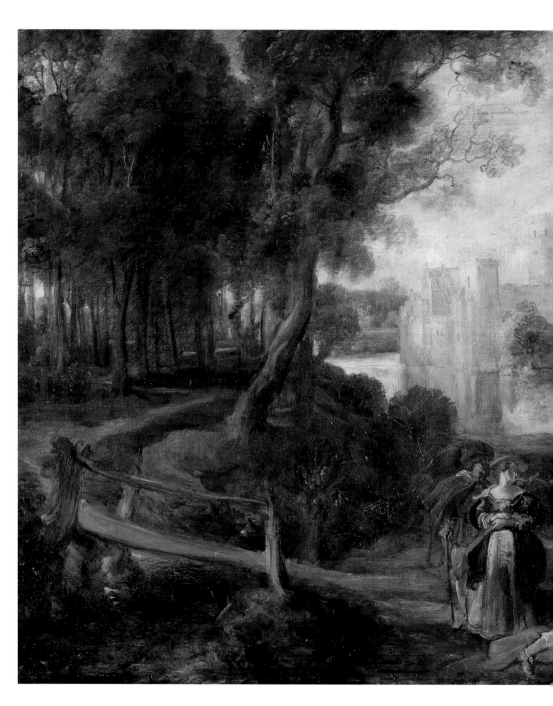

The Castle Park, c. 1635/40
Oil on panel, 52.7×97 cm
Kunsthistorisches Museum, Vienna

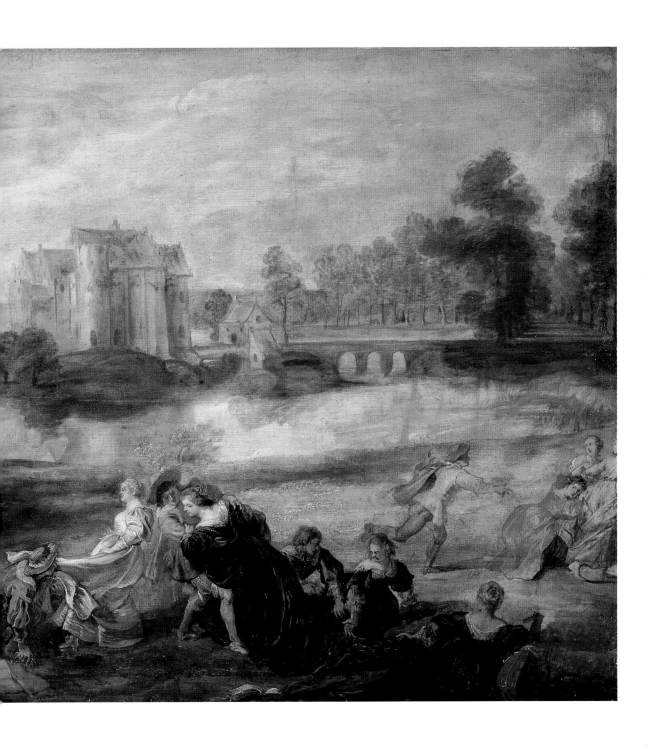

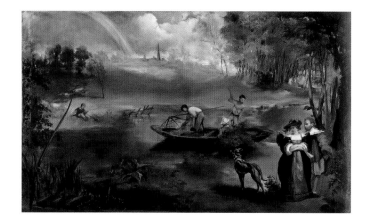

Edouard Manet, *La Pêche*, 1861
Oil on canvas, 76.8×123.2 cm
The Metropolitan Museum of Art,
New York

Metamorphosis

Peter Paul Rubens' paintings have made a lasting impression on our image of love and marriage to this day. Time and again fellow artists have quoted Rubens and his wife Hélène more or less directly from the fount of history. The dandy Manet took the plunge and married in 1863, while his friend Baudelaire smelt treason and dispatched rude remarks into battle against this bourgeois attack on bohemianism. Nonetheless, the bridegroom was aware what he owed the *promeneurs* in the clique who loved the bliss of being single and produced a strange picture that presents his own plans with a certain ironic detachment. *La Pêche* (The Fishing Catch) is full of historical allusions as an idyllic landscape citing the style and costumes of the seventeenth century, but it is also a paraphrase of Manet's real-life situation. Or more accurately, motifs have obviously been taken from Rubens and put together in a way that made them very relevant even in the

distorting mirror of Paris in the 1860s. The intellectual game has several protagonists, but they are not all allowed on stage. Front right, standing in the light, is a handsome couple almost like the one found – along with other amorous couples – in Rubens' *Castle Park* in the Kunsthistorisches Museum in Vienna. The man glows in flaming red and pays court to a lady decked out in an opulent but countrified manner. This masquerade without masks shows the painter Manet and his bride Suzanne Leenhoff. A rather amusing touch is that the couple's ten-year-old son Leon also makes an appearance. Manet shows him on the opposite bank of the river beyond the bow of the fishing boat. A lot of artistic effort is required for this pun, based on *pêcher* meaning 'to fish' and *pécher* 'to sin'. In this way, a persiflage of an ideal image is made in anachronistic costume – namely that of the Arcadian love garden and the redemption of its promises through marriage, wholly in the way Rubens painted, in many versions, and exemplified personally in his life. However, this persiflage is clever because it picks up on something that has been lost by people of an age that was sceptical in principle and yet, for all the irony, it manifests respect for art and the life of Peter Paul Rubens. Baudelaire incidentally allotted a special place to the great old master in his imaginary 'Museum of Love'.

"The loveliest treasure of his life" –
An exquisite double-portrait

The wife of a painter, sitting majestically, strikes an
elegant pose together with her son, on the terrace of a
palace. The picture has almost everything required of an
aristocratic portrait in its seventeenth-century solemnity:
elegance and beauty, wealth and nonchalance, lavishness
and harmony. Only the formality of court ceremony is
missing – but that has not been sought here, in fact the
picture exudes an air of privacy. It is Peter Paul Rubens'
homage to his young wife and an expression of gratitude
for the life granted to him at her side. It seems to have
been executed so simply and straightforwardly that one
could almost forget the actual dimensions of the picture.
These are what lift the painting beyond the fashionable
portrait formulae of love and youth, beauty and noblesse
to show a sincere, multi-facetted intimacy. The whole
superb artistry of an epoch-making painter is brought
to bear in this graceful and yet serious composition of
naturalness, experience, sensitivity and colour.

 Hélène Fourment is the name of the lady and she
was the second Mrs Rubens. Little Frans, perhaps three
years old, sits naked in her lap, dangling his legs. The two
of them are turned towards one another in familiarity,
though Frans casts a quick, wide-eyed glance over his
shoulder, making the feather in his black cap bob up and
down, and his arms seem ready for mischief. His secure
position in his mother's arms does nothing to curb this
wriggling hint of childish vivacity. Hélène holds her little
son with her hands loosely clasped behind his back.

Hélène with her Eldest Son Frans,
c. 1635
Oil on panel, 146 × 102 cm
Alte Pinakothek, Munich

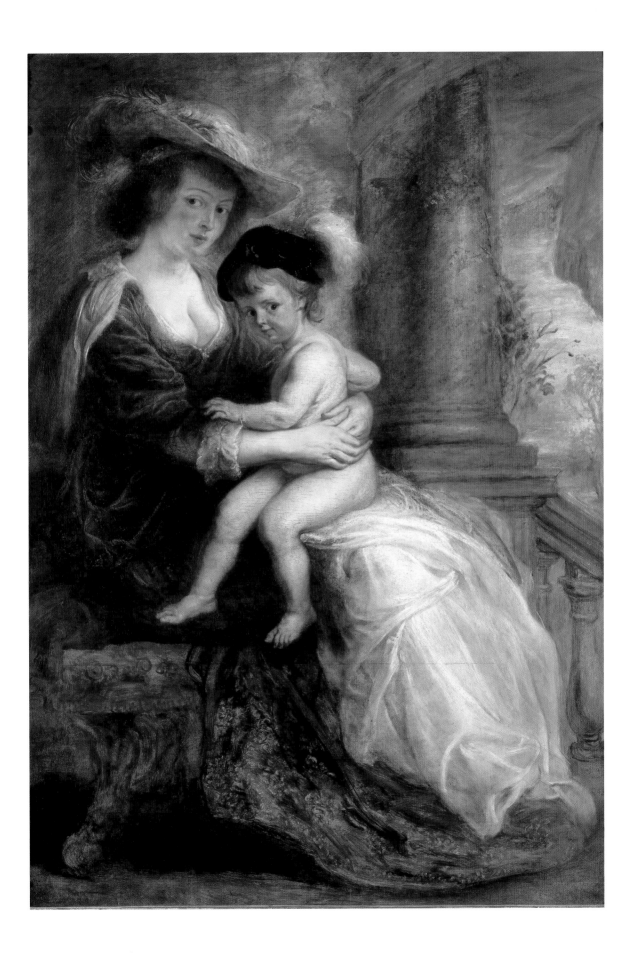

She has seated herself on a broad upholstered stool in an informal, homely dress, no doubt so her husband could paint her. She leans fondly towards the boy, her face and the tilt of the head exuding self-assurance and attentiveness. The broad, melodious curve of her hat casts a hint of shadow over her fresh, youthful face and unpretentiously styled hair. The light on her cleavage in the low-cut dress is thereby all the more conspicuous, drawing attention to her erotic charms and maternal qualities in equal measure. She is a woman who needs no jewels to be beautiful. On the right, a shiny marble column draped in red stands beside her almost as a matter of course – the touch of opulence is nothing out of the ordinary, however, because, like the tendrils and the bushes, it is very much part of the garden surrounding the home.

Another person plays an important role here, too. The two figures are looking out of the picture and, as their eyes encounter the viewer, there is the possibility of him intruding on the scene. But Hélène's does not let that effect her posture; her head scarcely turned. Frans on the other hand finds things more difficult. His face is almost frontal to the viewer, while his body is turned towards his mother, the contrary motion of the body expressing restlessness and conflicting feelings. It is only at hip level that the body is in balance and stable. Thus, despite the tranquillity of the scene, there is a great deal of movement. The energy in the billowing red curtain bursts the frame and poses the question as to what is actually causing it to billow so violently when everything else is motionless. Patches of light illuminate Hélène's

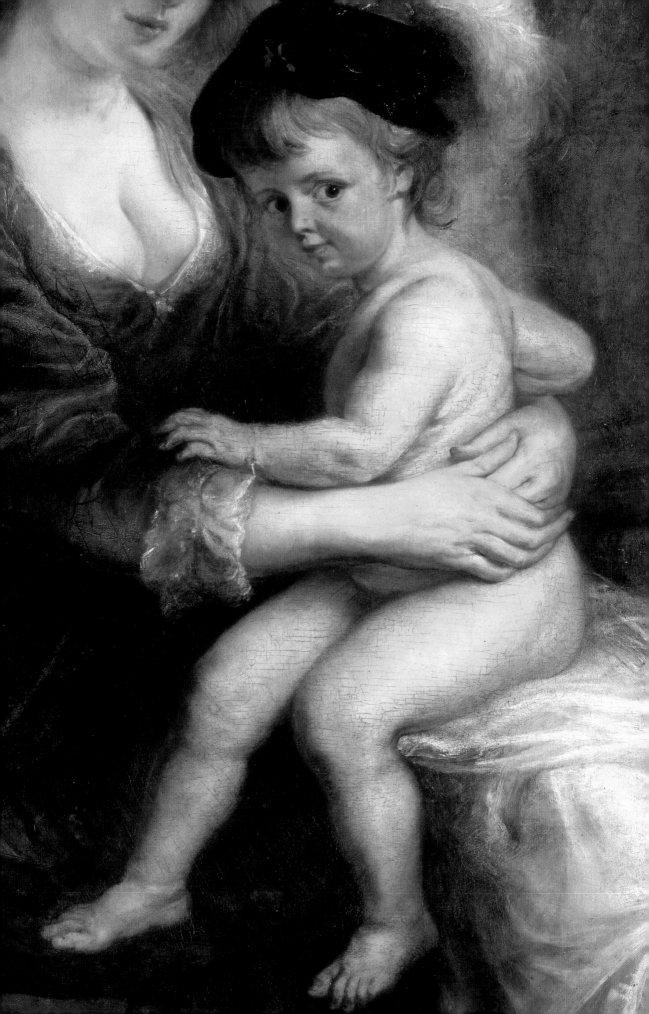

feather hat, the collar of her dress and pink décolletage as if shining through gaps in an overcast sky, but the child and the trimming of the mother's frothy white underskirt are lit from a steady light source coming from the front right.

This gently introduces a contrasting feature into the painting. The inverse sitting positions of the mother and child form a strong motif. But there is also a contradiction between the opulence of the heavy fabrics Hélène is wearing and the nakedness of the child that is only bridged by the contrary positioning of bare forearm on bare forearm. Moreover, the arrangement of axes and colour leave Frans in the foreground of the picture, while the body of the mother and the column constitute shadowy vertical volumes that outline the bright flesh of the boy, pushing him forward. The varnishing, or rather the sketchy overlapping of translucent layers of paint, create a deeply glowing, light-saturated materiality, the overall tone of which serves to render visible the warmth of feeling between Hélène and her son as something physical. Only in the representation of the child is there a contrapuntal element to this gentle softness – and for good reason. Frans is drawn very precisely with a sharp outline, whereby the child's head abruptly seems close-up optically. The sudden dense black of the cap, a colour which appears only here, reinforces this, drawing attention to the alertness of the gaze from dark eyes.

What does this all add up to? Rubens was in his late fifties when he painted the picture, more experienced than virtually anyone else in painting techniques. Though his intentions may not be fully represented in

the condition of the painting today, the picture has not been spoilt by over-painting and subsequent cleaning. And what is the intention behind the subtle breaks in the picture structure? The scene is not to be thought of as a snapshot, a fleeting record of a family memory – the complex structure of wooden panels that make up the picture in its final format and the changes Rubens made to the initial arrangement of the figure formation shows the inventive mind of the artist at work. Nor can it be a depiction of a pre-existing situation. In Antwerp, where Rubens lived, there was no monumental garden architecture of this kind in which Hélène and Frans could have been so casually slotted into in this way. As the picture must have been intended as it is and not otherwise, for all its sketchiness, the *mise en scène* must have had a purpose.

Sir Peter

The life of Peter Paul Rubens has a fairy-tale quality about it. It began with his father escaping from being executed only by the skin of his teeth in the wake of the most scandalous romantic affair of the day, and ended in Het Steen, one of the most splendid aristocratic houses in the large, old port of Antwerp. As a painter and diplomat, friend and humanist, Rubens was successful at the courts of Europe and popular among the people of his day; he was 'born to please', it was said of him. He used his manifold talents with industry and prudence. Even if

the human worries of a life lived in unhappy times did
not leave him untouched, Rubens's career as a child of
fortune was something he single-mindedly fashioned for
himself. He experienced none of the petty bourgeois toil
with which so many Netherlandish painters eked out
their existence, and even the modern taste for the misun-
derstood genius does not apply to him at all. A man of
the world, he was showered with commissions and mis-
sions, and was far too busy to play the melancholy artist.
His creative vigour, which extended to all subject matter
and formats, remained intact all his life and made him a
very rich man. Titles were offered to him as a highly
privileged diplomat by monarchs never disinterested in
furthering their own purposes. This brought Rubens not
only honour and standing, but also exemption from the
rules of the artists' guild and from taxes. And yet – at
the peak of his career he turned his back on court life
and finally returned to his real profession. That was in
1630, when he had long achieved socially what a painter
could achieve in the seventeenth century.

"I now lead … a quiet life with my wife and my chil-
dren and have no other desire in the world than to live
in peace." Rubens was fifty-seven when he wrote these
lines. In the years after the death of his first wife, Isabel-
la Brant, he had lived an unsettled life, always on the
move. He had worked as a diplomat for Philip iv and
the Habsburg Infanta of Spain and ruler of the southern
Netherlands, which took him to Spain, France and Eng-
land. His diplomatic successes proved short-lived and
illusory. Conflicting interests between Spain and Eng-
land ran too deep and were too complex for the powers-

Self-Portrait, after 1635
Black chalk, highlighted in white,
64×28.7 cm. The Louvre, Paris

16

that-be to agree to a lasting peace just for the sake of the Netherlands. Rubens gave it up with the attitude of a stoic, which indeed he had been from his youth. He wanted to escape the endless discord of the world, and just paint and enjoy his happiness. He remarried in late 1630, his new wife being Hélène Fourment, the lady in the painting now to be found in the Alte Pinakothek in Munich.

To live 'in peace' was asking a lot in those years. The Thirty Years' War was in full spate, and Germany was a permanent battlefield. Things were not much better in the Netherlands. When Rubens was born in Siegen (Germany) in 1577, the Lowlanders had already suffered ten years of war and Spanish occupation, some of them under the terrible Duke of Alba. Another seventy would follow, off and on. In 1576, Rubens's hometown of Antwerp, once a miracle of northern maritime commerce with its carved house gables and prosperous businesses, was plundered by the Spanish Habsburgs with apocalyptic thoroughness. The blockade of the Scheldt by the breakaway Dutch from 1585 sent Amsterdam's great, dangerous rival spiralling into a decaying commercial backwater. "It is heartbreaking to see everything is so desolate, indeed the whole city is so, because no great ships come thither any more, only small, single masters, and few enough even of them. All commerce is in ruins, where forty or fifty years ago such a wealth of goods is said to have been brought from all parts of the world that no commercial city of its like in the world had seen before. Now, instead of merchants and traders, there is no-one to be seen other than Spaniards swaggering

through the streets." (Travel account by Johann Wilhelm von Ramssla, 1620). The populace left in droves. This was another reason why the Habsburg rulers were anxious to promote Antwerp's importance at least as a centre of Counter-Reformation culture. The propaganda of pictures was part of this, which meant it was a favourable time to be a painter with talent. Founded in 1608, Rubens's studio flourished like no studio before, and over the years acquired the character of a minor court household. The gallant Sir Peter wooing the hand of the sixteen-year-old daughter of a neighbouring patrician did not, therefore, need to fear being rejected by Hélène.

Peter Paul Rubens was undoubtedly a good-looking man. In the handful of psychographically reticent self-portraits he liked to show himself with the dignity of personal detachment, looking at the viewer not just with self-assurance but also with gentle composure. There is none of the brooding, endless self-questioning of a painter like Rembrandt. Rubens was the irreproachable gentleman and *grand seigneur*. The broad, high forehead had cast off its brown locks fairly young, which merely enhanced the prominence of his large dark eyes. A carefully tended blond moustache and Van Dyck beard framed his full lips, while a long, narrow nose and arched eyebrows were prominent lines in a fleshy face. In his self-portraits, Rubens liked the urbane sweep of his large black hat because it emphasised the face with *chiaroscuro* contrasts and enriched his calm, intelligent physiognomy with a touch of *grandezza*.

A feel for *grandezza* was not of course something one learnt in Antwerp even in the early seventeenth century.

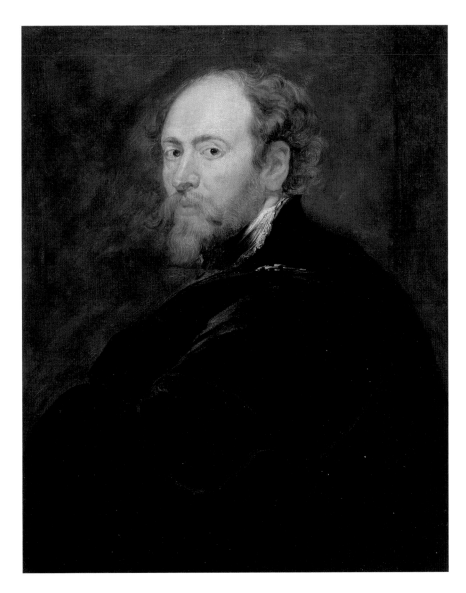

Self-Portrait, c. 1602, oil on panel
78×61 cm, Uffizi Gallery, Florence

In spring 1600, Rubens set off for Italy. These were his years of itinerant study after his training with home-based luminaries such as Adam van Noort and Otto van Veen. Going to Italy had been the accepted thing among Netherlandish artists for nearly a century. They all wanted to see the much-lauded masterworks of the great Renaissance artists with their own eyes and show their reverence for the glorious legacy of antiquity. Original spirits such as Jan Gossaert and Pieter Bruegel had had very different experiences of Italy, thereby infecting Netherlandish artists with curiosity. Whoever considered themselves to be anybody generally made it to Rome despite hardships, stayed there for a few years and then returned home to live off the spiritual nourishment of the great experience – professionally with an enhanced reputation and socially as an expert, one of the Romanists in the guilds of the Netherlandish cities.

However, Rubens's experience of Italy was quite different from that of most of his colleagues from the northern painter guilds, benefiting from something akin to a scholarship to study the art of Italy. Either in Venice itself, where he studied the pictures of Titian, Tintoretto and the elegant Veronese at close hand, or in Flanders, where Vincenzo Gonzaga went to take the waters, a courtier of the latter prince took a liking to the young *fiammingo*. This is how Rubens came to find himself in the eccentric duke's entourage at the court of Mantua in the summer of 1600. The Mantuan palaces and collections, which had once been under the jurisdiction of Giuliano Romano as major domo of the arts, were themselves highly propitious for an ambitious art student.

Rubens also travelled up and down Italy with the prince and made use of the military adventures of his master, who did not require his presence at court, for his own prolonged excursions. However, the ultimate goal of his dreams as a painter and humanist was Rome and, in July 1601, he fulfilled his ambition, reaching this Mecca of all artistic ambition for the first time.

At the beginning of the seventeenth century, Rome was where the action was as far as European painting was concerned, and Annibale Carracci and Caravaggio were the chief artistic personalities there. Within a few years – Carracci arrived in Rome in 1595, and died there in 1609, while Caravaggio left Rome in a hurry in 1606 after being involved in a fatal brawl – they razed the last bastions of Mannerism. Both retained the High Renaissance concept of volume and Michelangelo's radical modelling of the human body, but the end results were vastly different. Carracci produced unambiguous, strongly outlined figures whose physicality is engendered mostly by emotionally charged actions. They clearly and firmly define the composition. Spatial depth is an imperative in the depiction of bodies and clothes. In place of the pretentiousness of the last phase of Mannerism, a natural front and back of limbs appears. Strong, highly contrasting local colours enliven the pathos of the scene. Caravaggio is quite different – in his highly dramatic pictures, light is the dominant element. It is the force of lighting that lends the figures presence and almost oppressive closeness. Areas of bright colour contrast with the darkness of the background. And regardless of the moulding of specific shapes, one could learn from

Caravaggio how the graphic reality of objects can be put directly to the service of the picture's import. Rubens explored these pictures in drawings and copies, and made drawings of what antiquity had to offer. With charcoal, chalk and ink he composed a history of Italian art in terms of figures for himself, revealing how they could be varied and used compositionally. He produced hundreds of sheets recording and trying out what interested him artistically and, therefore, seemed important to him. There were several reasons for Rubens' constant and tireless execution of pencil drawings. Firstly, Rubens wanted to identify and clarify the qualities that make up a work of art. Drawing required accuracy of the eye and a precise hand. In putting things down on paper, Rubens – like most copy-artists – uncovered the essential features of the original works he was analysing. He could work out what gave them quality. A second, hardly less important reason for recording what he saw was his awareness that it might be his only opportunity. He could not know if he would ever see the original again. The studies preserved the spectrum of what he thought and saw during his analysis of the works of great predecessors. This fund of knowledge would be an inestimable treasure when he set up his own workshop.

The years in Italy gave Rubens's rich imagination sufficient artistic assurance for it to become 'useful', as he put it, and mature into a capacity to come up with unlimited, inventive pictorial narratives. He now combined the northern preference for broadly decorative scenes with the monumental power of Italian configurations of body and colour and, in this way, established

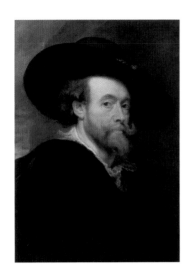

Self-Portrait, c. 1623/24
Oil on panel, 86×62.5 cm
The Royal Collection,
Windsor Castle

a style of his own. In it, he would henceforth have the immense corpus of classical mythology and western Christianity, man and nature at his fingertips, and originate his pictorial themes from them. For abstract things, the expressive armoury of subtle allegories was available. The appearance of everything natural he filled with robust vitality regardless of genre, because he had all genres in his repertoire. And the Italian years also meant something else – Rubens trained himself in the ways of the *cortigiano*, the multilingual, broadly educated man at court. His first independent diplomatic mission (in 1603) took him and a precious cargo from Mantua across the sea to the Spanish court. It was an adventurous trip, during which the young man from Flanders also had a chance to study masterpieces by Titian, among others – an experience he was never to forget.

Thus equipped, Rubens returned home to Antwerp in 1608. He was still in two minds whether to move to Italy for good or settle by the Scheldt. But the situation was decided for him in 1609 quite brilliantly when he was appointed court painter to the archduke in Brussels with an annual salary of 500 florins and complete freedom of movement, while still being allowed to live by the Scheldt. It was time to set himself up.

"In the dawn of love" – The Honeysuckle Arbour

Isabella Brant was hardly eighteen when she married
Rubens in October 1609. When she entered his life,
the painter discovered a new gift – he could find real
happiness in marriage, which was very unusual in an age
when this institution served principally as an instrument
of material security. A portrait study he painted of
Isabella in the second decade of their life together con-
ceals in its mastery the artist's total devotion to the
model and his urge to reveal the familiar character visu-
ally. It is there in the picture anyway, but Rubens also
expressed his homage to his first wife in a letter to a
friend after her death: "It is true, I have lost my good
wife. One could love her, could not help but love her,
quite justly, she had none of the faults of her sex, she
was devoid of moods and female weaknesses; she was
so good, so true, loved in life for her virtues and now
mourned by all after her death. Such a great loss seems
to me worth great feeling. Since then the only remedy
for all sorrow is oblivion, the child of time, I must doubt-
less hope for help therefrom. But I find it difficult to
separate the grief for what I have lost from the memory
of the woman that I must love and honour as long as
I live." (15 July 1626)

 Probably not long after his marriage – and for the
first time – Rubens showed clearly what, in his view,
marriage was actually about in the *Honeysuckle Arbour*.
The painting is an expression of supercilious artistic
pride while, at the same time, revealing a sophisticated
programme. It documents everything he had achieved

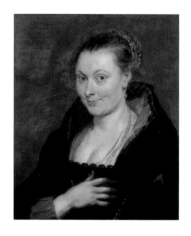

Isabella Brant, c. 1620/25
Oil on panel, 53×46 cm
The Cleveland Museum of Art

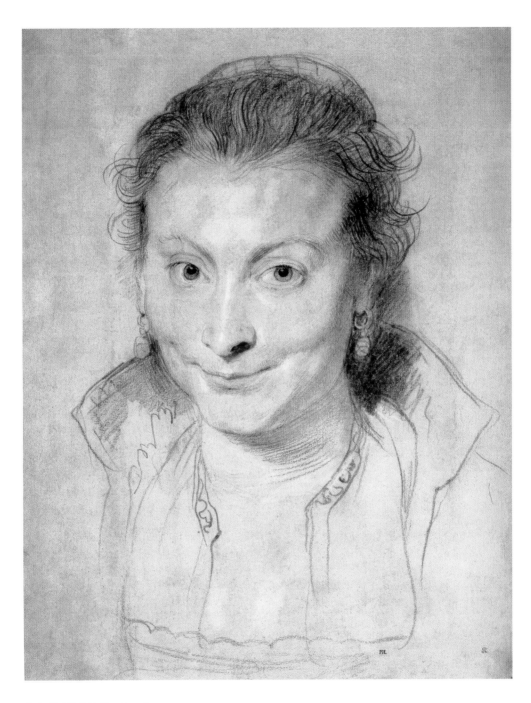

Portrait of Isabella Brant, c. 1622
Coloured chalks, 38.1 × 22 cm
The British Museum, London

around 1610 in terms of standing and is simultaneously a promise for their joint future. Of course, the thirty-three-year-old painter shows off the luxurious standard of living he can offer his young wife. Only the crossed legs indicate his profession to the knowledgeable eye. Even in the Middle Ages, this was an attribute common to scholars and artists. The twelfth-century Tyrolean poet Walther von der Vogelweide found sitting 'on a stone' (*ûf eime steine*) to be a comfortable pose for *otium sapientis*. In the picture, the couple's dress is expensive, the colours considered – silk, lace and embroidery *à la mode*. Were the rapier not so discreet and casually held, it would be presumptuous, as Rubens was not at that time a member of the aristocracy. But it looked just the thing for a man who had learnt to disguise material ambitions as the obligations of gallantry, as the age demanded.

A casual gesture with the index finger of his left hand directs the eye from the guard of the rapier to the couple's entwined hands, the evergreen standard pictorial formula to indicate marriage. The motif is repeated iconographically in many details. According to Alciati's book of emblems of 1542, just sitting firmly is a visual code for unswerving fidelity. Also, the external outline of the two figures strives for the ideal of a closed circle, thereby echoing Plato's notion of man's former spherical shape, whose component halves Eros brings together again in love. The isolated human couple in a blooming landscape recalls the raptures of Paradise. And finally the honeysuckle tendrils, to whose protection Rubens confides the scene, are a symbol of the permanent togetherness of man and wife. Yet Mr and Mrs Rubens in the

Rubens and Isabella Brant in the Honeysuckle Arbour, c. 1609
Oil on canvas, 179 × 136 cm
Alte Pinakothek, Munich

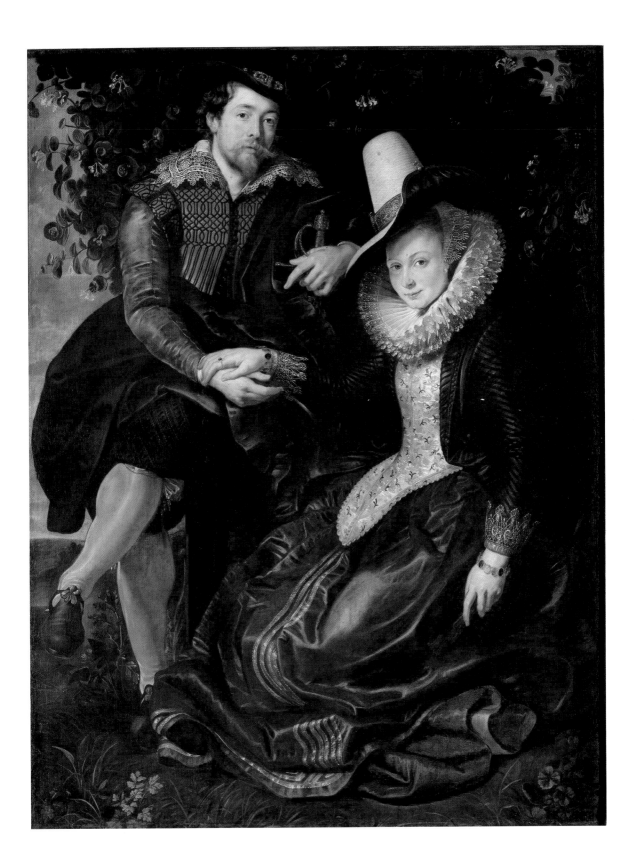

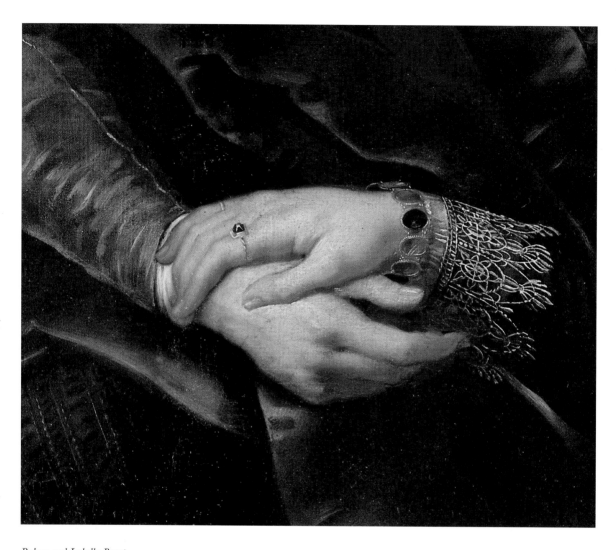

Rubens and Isabella Brant
in the Honeysuckle Arbour (detail)

Honeysuckle Arbour do not look at all as if they had gone to great lengths to adopt all these stereotype scholarly details correctly. In reality, with these foreground signposts in his picture, the painter is simply laying a trail to a much wider thematic horizon.

Up to this time, there had been no full-length, life-size portraits depicting bourgeois subjects. But Rubens needed the size of the figures. The real human proportions give the viewer something of equal status to look at – he is confronted with the Rubens' in the true sense of the word. The shallow depth of the pictorial space scarcely allows for distance. However, the large areas of colour constitute optical barriers that resist access, rendering the figures difficult to approach. On the other hand, the couple's togetherness as a pair is shown to be a self-evident, natural act of will by the relaxed lightness of gesture. The linking of the hands is not a seal on an emotional pact sworn under oath but an attitude of normality expressed with maximum self-assurance. Isabella has laid her right hand on that of Rubens in a gesture of undoubting claim, and he has willingly consented to be taken possession of. At the same time he supports her gesture and returns the feeling expressed in this manner, with a light hand. This dialogue of hands constitutes the unforced focus of their togetherness and the picture. That is the point to which the composition of details in its variety of nuances always returns. A particularly fine detail that brings out the whole genius of Rubens as a painter is that the brim of Isabella's hat caresses the back of her husband's left hand with biddable elegance, gesturing – one might say, of course – towards their linked

hands in the middle. The element of contradiction between the allusions and static harmony of the scene and their apparent inaccessibility brings us to the heart of this double portrait. The couple present themselves in aloof accord; unapproachable, but completely secure in each other. Thus, as the painter wanted, the two of them – even Isabella sitting on the ground – can look down at the viewer in a detached and almost challengingly way. The marriage is here the joint expression of the desired, hoped-for existence of two freely acting characters.

The composition of the painting is thus to be considered from the point of view of content, lending the objective world depicted in detail adequate credibility. The artistically created meaning does not arise from what Rubens depicts but through a much more meaningful logic in how he places his figures, arranges them together and formally shapes them. The foliage behind the woman is to be seen as a *hortus conclusus*, while the world on the man's side is open to the horizon. The duties of the partners are thereby separated and distinct. There are also illusions in the fashioning of the clothes. Isabella's yellow silk bodice encloses her slender body like an elegant harness and, in combination with the distancing lace ruff, creates an aura of ceremonial sublimity. Respect is due to her status. In contrast, the shot silk of the gown below her hips is full of life. Wilfully, the gown has draped itself over the firmly anchored foot of the painter and, just at this point, Rubens paints a multiple gold hem that vanishes under the stiff lap-piece of Isabella's bodice. This – erotic – capriccio evokes the pleasurable, vital side of their mutual happiness. Part

of it is also the painterly sophistication of the setting in which Rubens depicts his sensual admiration for his wife's beauty. The blinding white ruff catches the light from above and lights up Isabella's face from below. Even the smallest detail is thereby illuminated despite the shadow cast by the hat, so that the face can radiate almost supernaturally. It makes the natural arrangement of light and shadow that Rubens finds good enough for his own portrait look utterly plain in contrast.

The *Honeysuckle Arbour*, like nearly all Rubens's pictures, shows that this is a painter whose every brushstroke has to be taken seriously. The same is true for the picture of Hélène Fourment and her son Frans, painted twenty years later – except that, there, his pithy technique would reveal even greater artistic deftness.

Two Madonnas

The image of a young woman with her son in her lap is, art-historically speaking, the standard Virgin and Child configuration in Early Christian and mediaeval art. Rubens was quite uninhibited in his use of the type, transposing it without a qualm to the sphere of private life. And why not? After all, the Virgin and Child have been depicted time and again as a cosy group in playful togetherness. In such pictures, the numinous aura is replaced by the homely, human element. Yet the original image always remains recognisable. The figure of a seated mother holding her son in her lap is the traditional configuration of all Madonnas. If such a familiar arrangement is transposed into a portrait, it generates overlays of meaning that require explanation. But in his composition, Rubens obviously had something far more specific in mind than commonplace iconography. When he first went to Madrid in 1603, he must have seen Titian's *Madonna and Child in an Evening Landscape* hanging in the sacristy in El Escorial, and he went to see it again with the young Velázquez in 1628/29 with as specific and well documented interest in mind. Nowhere had a better collection of the Venetian painter's works than the Spanish court and the king had permitted the Flemish painter to copy Titian's paintings. In those eight months, Rubens must have worked like a demon, coming away afterwards with a tremendous haul. His posthumous estate alone lists thirty-two copies of Titian works. They were the launch pad for the last creative period in Rubens's œuvre.

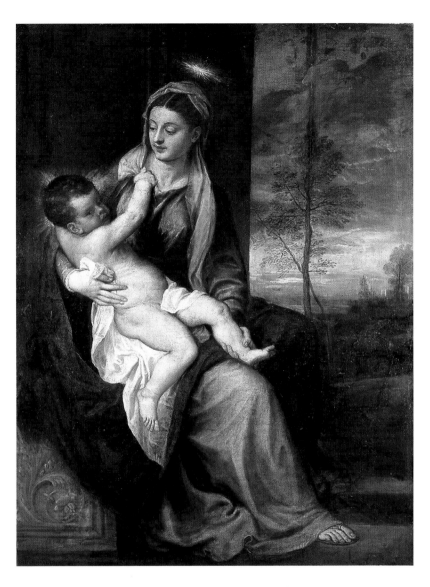

Titian, *Madonna and Child
in an Evening Landscape*, c. 1562
Oil on canvas, 173.5×132.7 cm
Alte Pinakothek, Munich

These days, the Escorial *Madonna* and the portrait of Hélène Fourment with her son Frans hang just a room or two apart in the Alte Pinakothek in Munich. Titian's picture, completed around 1562, is a very vivid, compositionally unique work on account of his treatment of the subject matter, proportions and colours. The figures are shown in a rather contorted wrestling motion, their proportions wholly unrealistic, but the scene is not immediately intelligible as convincing narration. The sacred aspect of their existence is represented by colour. Softly nuanced but cool in colour values, the mother-son group is set against a yellowy-red twilight, which generates an aura of mystery in the contrast of proximity and blurring. Though the physical appearance of the life-size figures is thereby invested with a powerful sense of presence, they do not acquire solidity. The figures lack all sense of illusionism. By using painterly techniques to divorce them from external reality, Titian is able to cast an aura of the spiritual over the objective world. The Virgin sits on a stone seat in front of a dark wall, clasping the conspicuously large and heavy infant Jesus to her. Miraculously, the weight of the child causes her no trouble, because natural considerations do not apply to her hefty physique. The steady, downward gaze seems almost capable of holding the child by itself. The Virgin figure must be seen in her totality, quite literally as the bearer of Christ, and then everything becomes clear – what is really important, to which everything else is subordinate to, is the boy in her lap. However, there is something obstreperous about the wilful rotation of his shoulders and head. The fleshy body thrusts forward

from the depths of the red and (unfortunately badly preserved) blue robes. The torsion of the body and incomprehensible pose between lying and sitting suggest a spirited resolve whose purpose is not clear. The flat pictorial stage belongs to the figure grouping. It breaks off abruptly and with a sharp caesura on the right, opening up the view to the cloudy sky and sunset of an evening landscape. Christ's mission will be fulfilled out there.

The parallels between the two paintings are easy to identify. Rubens of course recognised the enigmatic nature of Titian's composition for what it was, and admired it. But however entertaining it might be to track down the similarities in detail, they are not what matters. The critical thing is what Rubens made of Titian's model. As he prepared to paint a portrait of Hélène and Frans, he obviously had no intention of doing a take on the Escorial Madonna. The process of genesis provides information on this point. Rubens began the picture – as Titian probably did as well – as an 'elbow joint'. X-ray photos show that Frans was originally dressed and his legs were covered, as in a similar picture now in Paris. The format then gradually expanded to its present size with the addition of further wooden panels to a size that is very close to that of the Titian Madonna. What were these changes for, if not for thematic reasons? By depicting mother and son, Rubens had ventured into long-established Madonna terrain. In view of his preliminary drawing with Hélène facing right, for the Titian devotee there was only one work that could offer thematic inspiration for his painter's imagination. Nevertheless, regardless of the theme, Rubens had developed his own

personal subject matter that summed up his contented situation in life, his experience and his artistic skills in a single picture.

The Titian Madonna broke the confinements of a long-established tradition. Up till then, the central feature of the *sacra conversazione* type, namely the multi-figure altar painting, had not been a full-length life-size Madonna. Normally the Virgin was depicted surrounded by various saints or accompanied by angels. The Munich picture dispenses with all such accessories and any narrative element, almost as if it were conceived according to the rules of portraiture. It is all the more conspicuous that Titian does not place his figures in the middle of the picture but shifts them in all their weightiness to the far left – because he needed the landscape for a view to the future. The altered weight of the composition is the first step in Rubens's paraphrase towards establishing a completely different pictorial meaning. The side view of the Virgin in Titian and Hélène in Rubens spreads the firmly-based seated position of the women across the lower half of the picture. The naked children are then placed into the opulent robes of maternal security. But whereas in Titian the situation seems ambiguous, enigmatic in its movements and far from realistic, Rubens strives for expressiveness in the splendour of naturalness. His son is clearly sitting, and likewise where he is sitting is firmly the middle of the picture. Titian creates tension by letting the axes of the bodies go different ways, while Rubens brings harmony by having them parallel. Thus, despite the differences in size and brightness, the relationship between Hélène and Frans is one of unpreten-

tious weightiness. As in the *Honeysuckle Arbour*, the fact that both are looking at the painter is turned into an expression of psychic concord. The act of looking also explains here the visible conflict in the child's twisted position – he is attracted both ways. In contrast, Titian's Virgin has no external referent, and is impersonal in the ideal nature of her holy function. There is no comprehensible motivation that could obviously explain the peculiar suspended pose of the child and his twisted trunk. Yet how fundamentally and precisely Rubens distinguishes between the sacrosanct and real life is clear from his re-interpretation of the pictorial space. Where Titian introduces a sharp caesura between the world of his figures and the worldly sphere of the landscape, Rubens places a column in the same position against the evening sky, thereby creating a homogeneous, completely secular spatial continuum.

This visibly contains fundamental elements of the pictorial concept, of course. The physiognomic relationship in the faces of the double portrait contradict the varying degrees of precision in the drawing and outlines in the representation, thus lending the painting certain distancing elements. In the Titian Madonna, it is repeatedly noticeable that blurred outlines and the fading out of areas of colour reduce the solidity of what the viewer sees. If this 'rough manner', to quote Vasari, is contrasted sharply and directly with a precise shape, an abrupt break is created in the visual experience between optical closeness and distance that can only be explained in terms of artistic effect. That is precisely what Rubens was aiming for. Frans looms visibly forward and is

thereby lent powerful presence, whereas Hélène fades away into the room. The contrast conceals a metaphor of time – the present represented by the child who also includes what is to come, the future. What is less precisely designated withdraws into the room and therewith retreats in time. With this wholly and deliberately profane approach to human nature, Rubens veers away from Titian's timeless ideal.

Portraits should record life-like images of sitters for posterity, preserve their external appearance and transcend the temporal. It is part of the painter's business to treat ugliness and the allegorical decoration of a character with forbearance. But Rubens was painting his wife and had no client breathing down his neck. Nonetheless, he did not dispense with the usual attributes of virtue. The column stands for strength and steadfastness, while beauty blooms symbolically in the picture as well. Moreover, Hélène and Frans are invested with great status, because they have to stand comparison with Madonnas. Yet there is not a breath of blasphemous presumption here as Rubens reduces the ostentation to symbolic modesty. Emblematically, the column with tendrils around it is a symbol of marriage that unites joy and sorrow with each other. The curtain, which could drop back from its airy fluttering at any moment, gives emphatic expression to the consciousness of impermanence. The same awareness shows in the orientation of the main composition from top left to bottom right, which is continued by the balustrade and prolonged into the unknown. Only Frans stands out from this orientation and cuts across it. As is his childish right, he is permitted to remain untroubled

by time. At the end of the picture's spatial structure is the evening landscape, reflected in the terrific red glow of the curtain. This is where the scene comes together as a sensory unity that, visibly and invisibly, embraces the double portrait. *Rubens* is the Latin word for 'reddening', and red is the complement of Hélène's moss-green jacket. The painter is thus there both in front of the picture, in the gaze of his family and in the depth of the work as a symbol for the end of the day. The discreetness of the personal element in this metaphorical presence may stand surety for the truth of what is depicted. What is seen is thus presented to us by the painter and the sitter as the reality of life. Rubens conveys this as a sensory experience with the sentiment of a man who was aware of his good fortune.

Ideal reality

The picture of Hélène and Frans derives its multi-layered content from various aspects of painting. Basic elements of the medium are of course picture composition and colour form, but Rubens also exploited the potential of the border area between objective precision and idealisation. To see only artistic intentions therein would not accord with the attractive philosophy of this experienced admirer of women, who in his own words had 'never sensed any aptitude for the abstinence of celibacy.'

Hélène was the focus of his life, a feast for his eyes and the target of endless new allegories – for Rubens, Pygmalion's dream had really come to life. His pictures and graphic attempts to capture his subject were, therefore, rather effusive. He effortlessly merged the real-life person of Hélène into the Madonna image, as we have seen. She can be seen in an astonishing number of other roles, too, sometimes in costume, sometimes without. Showily as Mrs Rubens, then bewitchingly perhaps as Andromeda, Aphrodite or Bathsheba, and finally even in mystic rapture as St Cecilia. Her external appearance corresponds to the notion of the living ideal, and it would seem that Rubens cheerfully went to work on any idea that allowed him to paint her. Though the model can indeed be ennobled by lofty subject matter, in return she breathes an air of reality into traditional and cultural context. In such cases, physiognomy and theme cannot be distinguished in terms of portrait and pictorial narrative, but fuse into one. The works painted between 1630 and 1640 present Hélène in various genres, like different

Andromeda, c. 1639/40
Oil on panel, 189×94 cm
Gemäldegalerie, Berlin

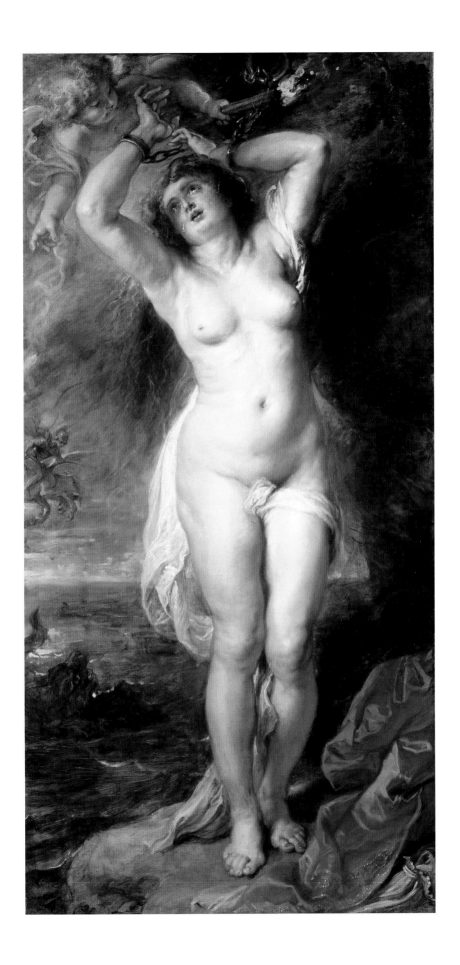

pitches at which the panegyric of her beauty could be sung. The spectrum ranges from portrait studies and life-size portraits to the multi-figure compositions in his history paintings.

Little more about Hélène is known than what the pictures tell us. She was the youngest child of a neighbouring family on the same street with many children, the eleventh of the Fourment siblings. Her father merited the term a wealthy man, having prospered as a silk merchant. Hélène's dowry of 18,000 florins was certainly an attraction, but her true appeal was for Rubens certainly another. She was considered *the* beauty in town. The archduke saw in her the perfect embodiment of a Venus for her husband's pictures – a remark that no doubt excited his royal brother of Spain's attention. In the early eighteenth-century, the art biographer Arnold Houbraken called the lady a 'Helen of beauty' in his work *Groote Schouburgh der nederlantsche Konstschilders en schilderessen,* maliciously adding – with the envious eye of a rather unsuccessful artist – that is was an advantage for an artist to be able "to save the cost of a model." Both aspects obviously fell in with Rubens's views. At any rate, he got down to work with zeal when it came to painting her.

"The loveliest woman you will find here" – Hélène in portraits

The Madonna-like mother-child icon was the focal point of a series of 'fair Helens' that would enrich his life's remaining output with works that were all the more valuable for being entirely by his own hand. He made a splendid start with *Hélène Fourment in Bridal Dress*. The title is traditional more than obvious, as only the orange sprig in her hair – budding and blossoming simultaneously – alludes to the wedding on St Nicholas's Day 1630. The dress of finest silk brocade would befit a bride of the highest rank, but apparently was also appropriate to the wardrobe of a rich Antwerp silk merchant's daughter. To the fabric dreams are made of, the no less well-to-do bridegroom/painter added (as meticulously noted elsewhere) a post-nuptial gift of gold and jewels in the shape of the massive jewellery the bride wears, plus all kinds of truly princely prestigious accessories such as the terrace, column, chair and billowing curtain drapery. Thus material and immaterial valuables (the latter in the shape of light and colour) provide a heady, lavish celebration honouring the young Flemish beauty with the merry button eyes. If we take the small preliminary drawing literally, Rubens steered a course between ideal and real, displaying his unusual gift for conjuring up bliss. The blushing girl with the dreamy, averted eyes has turned into a charming young woman, whose lustrous beauty and fresh, chubby-cheeked vivacity effortlessly outshine all status symbols. Both the picture and its subject have true class. Rubens focuses his attention

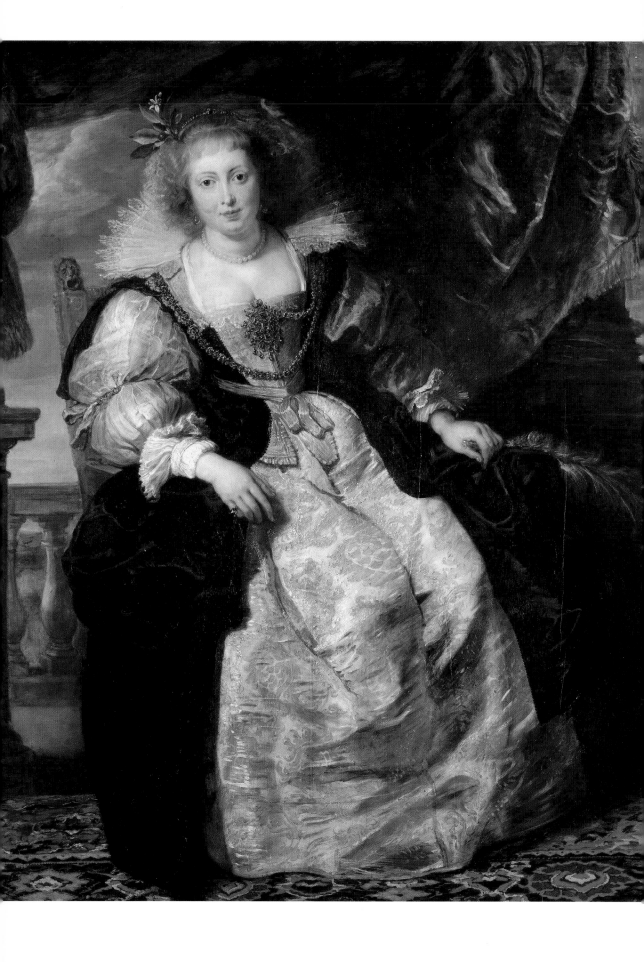

on the hair, and transforms the delicate bud in the sketch to a blossoming beauty in the painting. The artful trick of the model sitting at a slight diagonal turns the controlled pose shown in the drawing into one of spontaneous openness, direct attention and alertness – and indeed, bearing the absolute seriousness of her gaze in mind, into one of real affection, or even of love. This joyous, expectant look reflects the painter's tender feeling for Hélène, and focuses entirely on Rubens, as does the slight movement of the body under the rustling silk wrapped round it almost like gift wrapping. The picture is not a solemn portrait of a married couple like the *Honeysuckle Arbour*. It is a promise in paint, and Hélène is the very image of a bewitching bride, in fact all brides.

"May he who has lived through five decades receive what buds now into first blossom in you; he will grow young again in your arms, maid, and invigorating strength from your countenance will follow him." What Jan Caspar Gevaerts conjured up for his friend Rubens in the ponderous wedding poem – half pious wish, half fine prophecy – and all Antwerp willingly conceded to its celebrated star and honoured fellow citizen with a knowing grin, became glorious reality, at least in the picture. Particularly Hélène, dressed to go out, seems to have appealed to Rubens. Two portraits some seven years apart play on the stimulating situation of switching between private and public spheres. A chalk drawing of 1630/32 contains elements of both works – Hélène as a half-length figure, richly dressed, prayer book in one hand while adjusting her veil with the other. The technique and subject merge: painterly hatchings, finely

Hélène Fourment in Bridal Dress, c. 1630/31
Oil on panel, 163.5 × 136.9 cm
Alte Pinakothek, Munich

Hélène Fourment (study for *Hélène Fourment in Bridal Dress*), *c.* 1630
Black and red chalk, highlighted
in white, 48.8×32 cm
Museum Boymans-van Beuningen,
Rotterdam

Hélène Fourment, c. 1630
Chalk (black, red and white),
pen and ink on paper, 61.2×55 cm
The Samuel Courtauld Trust,
Courtauld Institute of Art Gallery,
London

distributed white highlights and delicate red chalk touches on the skin breathe life into the study and, in their fluid consistency, are wholly in accord with the shy softness of the model. The alert gaze from her dark eyes which, under a mass of hair and the shadow of the veil imbue the regular face with spirit, never cease to fascinate. This grave but melting look, intensified with emotion by slightly downcast eyes and an almost imperceptible tilt of the head, was no doubt indeed capable of giving the recipient that 'invigorating strength' that Gevaerts promised the middle-aged groom – and without the loss of distinction that often accompanied such 'mismatched' liaisons. The sixteen-year-old Hélène is very much a woman and at the same time a lady.

The two portraits are variants of the same subject. The prayer book vanishes in the Munich version from the early days of the marriage, to be replaced by a glove. Though according to Flemish custom the latter (in red and with a few coins) counted as one of the symbolic gifts to the bride, Rubens (and Hélène) appear to have been fully aware of the erotic significance of the charming accessory. The quality of the fur glove and where and how she holds it, suggest a thoroughly frivolous meaning. And as if one were still in doubt, the generous décolletage exposes the initial impression one gains to be somewhat farcical. Hélène's facial expression shows that the picture is entirely a private game – still the direct, sincere but knowing gaze, but here with the ladylike look pushed aside in favour of sex appeal with the hint of a smirking grin. Hélène was never younger than here. Glowing apple cheeks, her mouth pursed as if to kiss

Hélène Fourment Putting on a Glove, c. 1631
Oil on oak panel, 96.6×69.3 cm
Alte Pinakothek, Munich

48

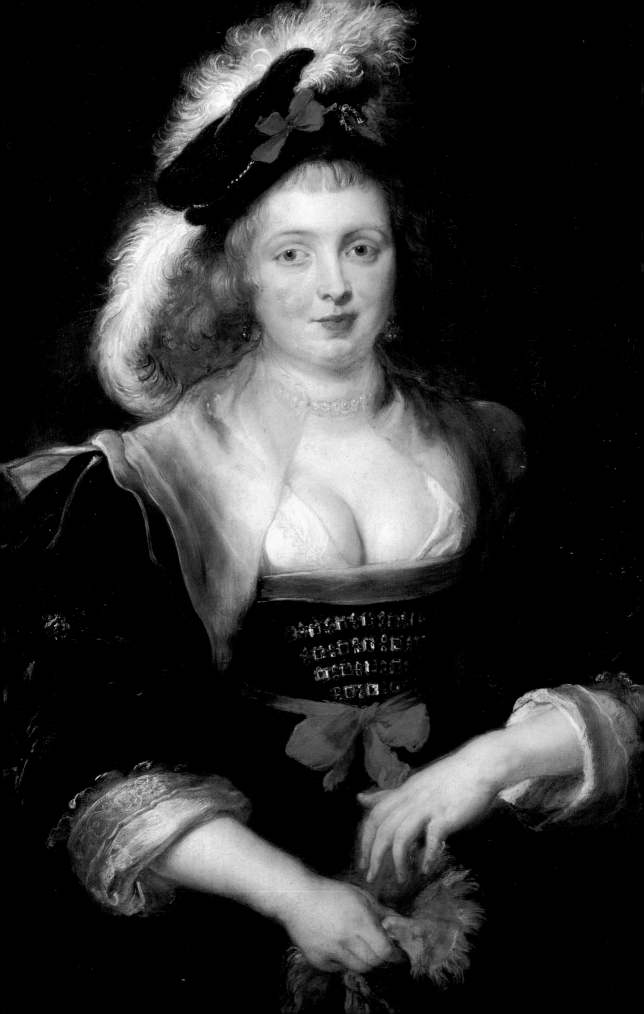

and a mischievously conspiratorial cheerfulness show
her for what she initially was in fact – a teenager head
over heels in love, ready to slip into any fantasy role she
read in the eyes of the one admiring and admired man.
But Hélène is no less conscious of good taste than her
husband, so that though it is all unambiguous, nothing is
overt. While the unpretentious pose, the dark velvet of
the elegant robe, the unostentatious jewellery and classic
triad of black, white and red bespeak the stylish lady,
this is offset by the rolled back cuffs, slight disorder in
the *fichu* and the jaunty angle of the cap. The minor
déshabille is to be taken as nonchalant casualness that
Hélène, the quintessential *jeunesse dorée* and accustomed
to the best of the best, puts on with the gown. At the
same time, the gown literally acquires a touch of the *neg-
ligé*, which belongs to the private sphere. The coquettish
red bows and cap feather that lovingly hugs the perfumed
hair and the soft finger, crooked as if in caress, turn
the young lady, for all her *noblesse*, into an affectionate
kitten.

There is no trace of this in the later portrait, *Hélène
Fourment Leaving her House*. The small cabinet close-up
picture becomes a distanced, large-format, full-length
portrait, the neutral background a sketched ambience
with eloquent indications that this lady is rightfully in
a distinguished setting and in every sense established.
Previously, Rubens had shown only the *Marchesa Brigida
Spinola Doria* and the *Countess Arundel* with this air of
wealth and rank which, since Titian's time, had been
reserved for public portraits of aristocrats. As earlier
in the bridal picture, Hélène is shown in the style of a

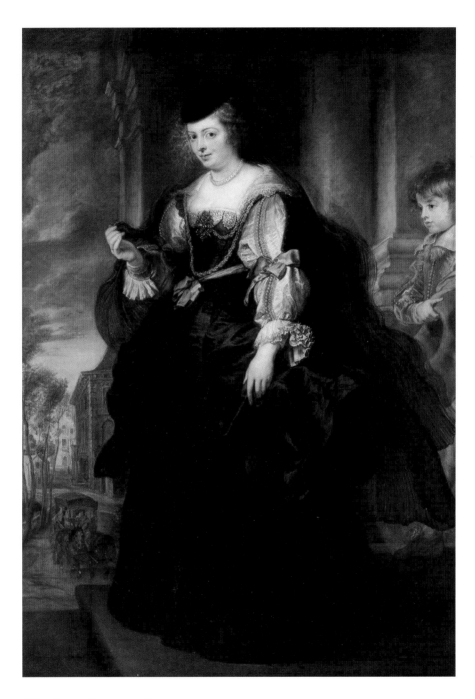

Hélène Fourment Leaving her House,
1638/39
Oil on panel, 195×132 cm
The Louvre, Paris

grande dame and the same jewellery is part of it – which is more telling of Rubens's attitude and assumption of rank than of the sitter. Consorting with the courts of Europe on both artistic and diplomatic missions had no way turned Rubens into a courtier, but he was nonetheless one who worked for princes. It was a status and way of life he could cultivate as a *grand seigneur* in the best Antwerp society, where the resident establishment had long considered itself as an autochthonous aristocracy with the appropriate savoir-vivre. As his self-portrait of 1627 reveals, as a knight Rubens needed to take off his hat to no-one, and he made use of this status – but at the same time permitted himself the freedom not to allow it to shackle him in any way. In 1634 he wrote to his friend de Peiresc: "I have taken a young woman of a good birth though bourgeois family, despite everyone trying to persuade me to marry a lady at court, but I fear the nobility's well-known unfortunate characteristic of arrogance, particularly among the opposite sex, and that is why I was pleased to take a wife that does not blush when she sees me pick up a brush." As in most of his letters Rubens adopts a finely sensitive tone. The words betray nothing of the feelings that he had for Hélène. The pictures are all the more eloquent. Instead of getting himself elevated to the nobility through a *mariage à la mode*, he takes his brush in hand and makes a bourgeois Venus into a noblewoman – *his* noblewoman – in the tradition of the king's son, Paris, who put beauty and love over fame and wealth in his choice of another Helen. The artists achieves this with a brush and, as the Paris picture shows, does it for a woman who is worth it. Is it due to

Marchesa Brigida Spinola Doria, 1606
Oil on canvas, 152.5×99 cm
National Gallery of Art,
Washington, D.C.

the maturity of his art or Hélène's natural appeal that she looks so much less cool and arrogant than Brigida Spinola Doria painted roughly thirty years earlier, despite the similarity of composures and pride in the surrounding opulence? Whereas the Genoese marchioness – originally likewise full-length – strides through lofty rooms upright and armoured like a lovely but icy mechanical doll, with Hélène the clothes and the pose look quite natural. A lady is on the point of leaving her house, her alert but reticent gaze incidentally catching the viewer's eye with a friendly greeting instead of the marchioness's condescension which forces the viewer to bow. Natural warmth and the bubbling security of loving and being loved, give Hélène that unforced self-assurance that makes a real lady. Here the dress in immaculate order with a slight widow-like quality due to its sedate black-white-violet colouring. If it were not for the merrily fluttering material and the pertly curled strands of golden hair, she might be taken for a respectable matron leaving her town house in the best district of the city. It was no doubt the contrast between the elegant, soigné respectability and radiant youth that fascinated Rubens in the subject, with the latter aspect picked up twice in the painting – the boy in the picture, his son Frans, born in 1633, looks as soft and childish just as Hélène blooms against the background as a womanly figure. The little page is also wholly at her service. Just like the architecture (which far surpasses the real-life Rubens house in grandeur), the boy's costume acts as a further indication of status, also replacing the standard curtain drapes as a colour accent. Though everything is

'draped' here too, the scene does not look overtly pompous or posed. The soft twilight and Hélène's warm radiance make even this 'state portrait' an avowal of love by the painter who, though not personally visible, is there in her gaze as a recipient of love.

Hélène's maternal bliss

Hélène is not always seen looking at her husband. With the five children born in ten years of marriage, the number of figures appearing in the portraits grows almost as a matter of course, as does the breadth of her attention. Seen in this context, *Portrait of Hélène with her Son Frans* is not just an incantation to happiness verging on idolisation in its Madonna pose, it also contains the dual loving gazes of wife and son for the husband, father and artist. However, the fact that there is not a single picture of Hélène with all the children together may be seen as a sign of Rubens's persisting infatuation with his wife – wouldn't the four little ones (the fifth died at birth) have stolen the show from the lovely mother in every way? This is just what happens in the unfinished portrait of *Hélène Fourment and her Children*. Though here too Hélène is the true 'shining light' and soul of the whole scene – the iridescent white of her dress reflecting the blue of the sky lends her an ethereal air – our attention is attracted to and comes from Frans who, while facing his mother, turns his head to look out of the picture. The quiet look over the shoulder suggests an interruption and makes any third party disrupt the profound intimacy with his mother. The rather oppressed appearance of his sister suggests that, not for the first time, he has taken the top spot – where the bossy little boy no doubt most likes to be. Like Clara Johanna, the viewer also feels somewhat marginalized by this rebuking glance and the absence of a look from Hélène. Her face in the soft shadow of the brim of her hat, she seems absorbed in her son and

herself. Her touching, almost sacred seriousness is still there but now seems directed more towards maternity than marriage. As if she had put aside the coquettish, attention-seeking mien with her new role, she is clad unusually simply. This time is not she but Frans who wears the pretty cap, its cockade triumphantly continuing the erect line of the childishly appealing head, just as her pensive, rather slumped posture is echoed in the down-turned feather in her hat. The fluidly sketched scene is as much a portrait of Hélène as it is a psychologically differentiated and at the same time rapturous picture of maternal happiness. The 'Madonna' of 1634 has become a 'Holy Family', with the elder sister in the role of St John – but without Joseph. The father is busy recording the domestic idyll with the brush, keeping meanwhile out of sight. Rubens was visibly moved by Hélène's maternal happiness and was a loving father to his children, but he was not transported into a passion of love at the sight of his beloved surrounded by a host of children. Thus, in the picture, he allots Frans the place occupied by Nikolaas, his youngest son by his first marriage, vis-à-vis Hélène some years earlier, depicted walking in a garden – namely that of the page and young cavalier.

Hélène Fourment and her Children (Clara Johanna and Frans), c. 1636
Oil on panel, 115×85 cm
Musée du Louvre, Paris

56

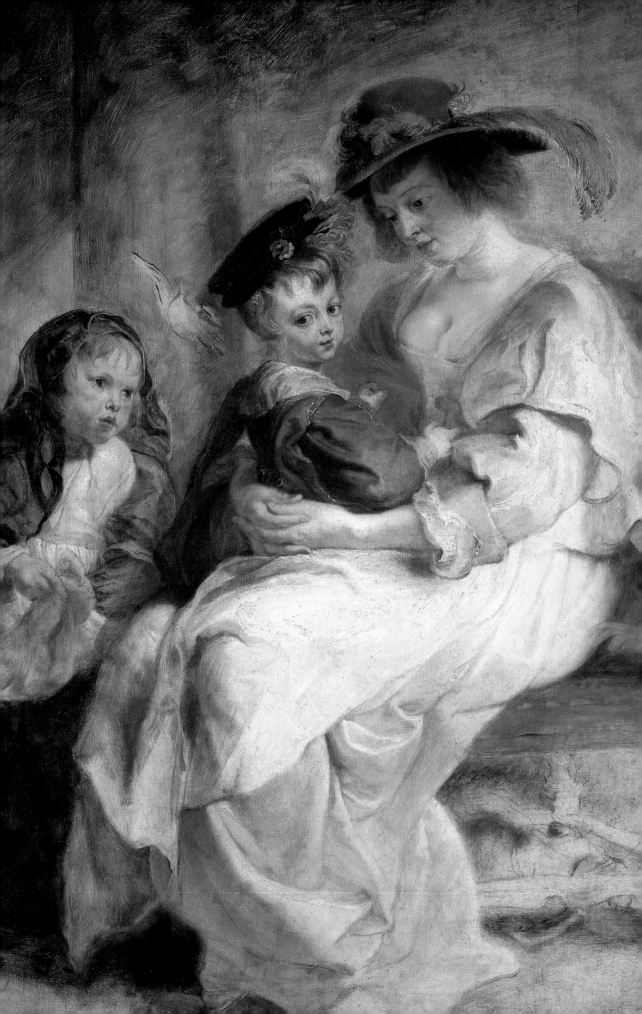

Rubens' 'Gardens of Love'

Rubens had owned his Antwerp house for twenty years,
when Hélène moved in. He added an Italianate palazzo
style extension to it to house his studio and laid out the
gardens as a park, thereby turning the stately old city
house into a nobleman's estate – an act of self-establish-
ment that had largely considerably influenced the nature
of his marriage to Isabella. When on his return to
Antwerp in 1630 he cut the Gordian knot of ambition,
he thus already had his comfortable billet set up. It was
not until 1635 that he ratcheted up his worldly status
another notch with the purchase of the palatial seat Het
Steen, creating a feudal framework based on the Ancient
Greek principle of *topoi* in praise of the country, reflect-
ing his newfound liking for country life. Though the
much-praised 'peaceful contemplation' mainly brought
him time for his 'beloved profession', the picture of
Rubens with Hélène in the Garden dated *c.*1631 still consti-
tutes an assemblage of all his 'treasures'. In the garden,
a view of an Antwerp garden idealised mainly in respect
of its extent, not only tulips and orange trees blossom.
The loveliest flower is of course Hélène who, in gleam-
ing white and yellow, forms the centre of the picture like
a true 'sunflower'. The straw hat, bodice and underskirt
go very well with her naïve, robust youth – behold, *la
belle jardinière*! Rubens and Nikolaas circle this 'sun'.
The walk is after all quite without any real objective –
strolling in 'nature' in the late-afternoon, while enjoying
its well-established artistry. The family itself is a piece of
well-arranged nature, not to say culture. Two peacocks,

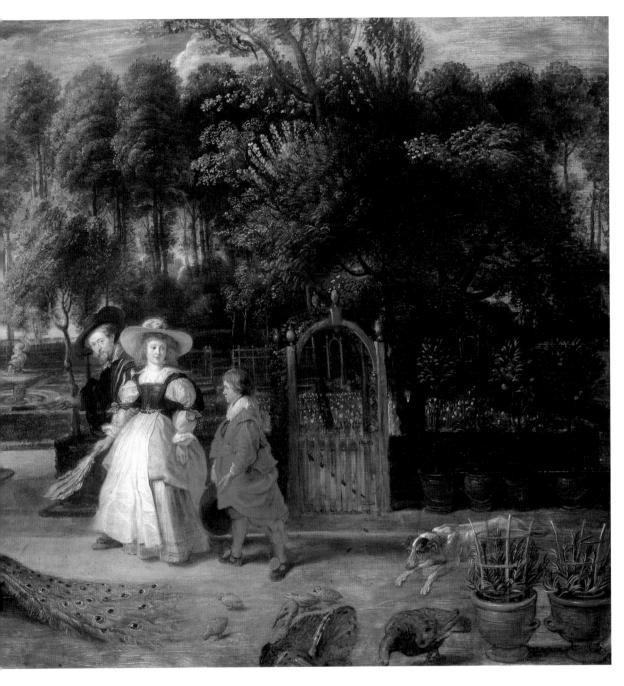

Rubens with Hélène in the Garden,
c. 1631
Oil on panel, 97.5×130.8 cm
Alte Pinakothek, Munich

attributes of Juno and thus the patroness of marriage
and family, summon up this image, and it is no mere
chance that the peacock's tail is laid at the couple's feet
like a red carpet. Like the two peacocks, the human
couple also seemed fused into one figure, reinforced in
the echo of the pair of trees behind them. Such a plethora
of dualities makes third parties into outsiders, and Niko-
laas's sullen mien is not just the naturally often secretive,
awkward appearance of a thirteen-year-old but reflects
the family situation. He probably knows that his step-
mother is the same age as his brother Albert. Even more
confusing, the new 'sister' is at the same time his new
mother, who is clearly as much at a loss as he is, the
latecomer left over from the first marriage. Everything
revolves around Hélène, and he has to revolve with it
and play the young cavalier. Yet for all the distance,
Nikolaas and Hélène are unconsciously another couple –
they are united in youth, and that is what is painted here
in the brightest colours. The trio almost constitute an
allegory of age. The rising line and typical behaviour
of the protagonists supports this idea, which is further
boosted by the servant to one side representing old age.
Rubens himself forms the zenith of the line falling to the
left and, just as he presents himself, somewhat touched
up, as in the prime of life (less kindly, one could say on
the threshold of old age), his son and wife each represent
other thresholds – Nikolaas that between childhood and
youth, Hélène between girl and woman. The awkward
bearing of the adolescent contrasts with the relaxed com-
posure of the mature man and indeed the advantage of
the ripe woman who knows the effect she has and how

to deploy it. A lot of tension for a harmless walk, in fact. Handling it requires instinctive tact by all participants. Rubens harmonises the balancing act by setting it in nature. It will all turn out all right, and indeed is already all right in this happy idyll, which with its unforced naturalness is a paean to orderliness, with regard to both nature and human life. The inviting gesture of the 'director' leads to the innermost part of this secular *hortus conclusus*, the middle of which is occupied by a fountain – a symbol of 'living' water. Dolphin fountain and pavilion, the latter once adorned with statues of Venus and Cupid and crowned by a figure of Abundance, are more than merely feudal insignia. They are Rubens's declaration of faith in love, peace and fertility in the sense of *amor vincit omnia*, a maxim that makes the showy pleasure garden into a personal love garden.

Even in the *Honeysuckle Arbour*, nature tamed in the garden is a metaphor for love happily 'tamed' in the bond of marriage. The walk in the garden makes a generic version of the subject. Around 1639, Rubens took up the subject once again. In *Rubens, his wife Hélène and their son Peter Paul*, the figures once again predominate over the garden setting. As in Hélène's portrait by herself, everything here is transfigured into opulence. A well overgrown with roses, a herm and a stone balustrade constitute a pergola, with a splendid parrot adding to the aristocratic aura. Its exotic beast reinforces the almost enchanted nature of the scenery, to which the hazy, sketchy painting technique also contributes, but at the same time the powerful harmony of primary colours in its plumage anchors the whole scene in reality. The

curved outline of Hélène stands out against a patch of blue sky. She looks more sedate here, and the age difference between her and her husband is less noticeable, without depriving her of any of her rosy grace. The couple's parallel coloration of dress and the position of their arms, plus their absorption in conversation with each other create a close togetherness, not least because this time Rubens brings himself into the picture as an 'equal' with his now mature companion. As in the *Honeysuckle Arbour*, he looms over his wife, but with his firmly balanced stance he is her prop and support – he has the leading role, but performs it sensitively and chivalrously, as the play of hands and attentive look show. He is leading her, while she is leading the child on a halter which Peter Paul junior does not notice since Hélène is holding the lead very loosely. All his attention is devoted to his mother as he tries to capture and retain her interest. Compared to his bright, compact and sharply outlined figure – where the yellow, high-waisted robe is a distant echo of the childish, naïve Hélène in *Rubens with Hélène in the Garden* – the couple seem to belong to the different, fairy-tale reality of the background, particularly emphasized by the slightly blurred faces. Actually, the cute little chap with his lively pose is the only proper 'portrait' in the picture. Against the poetic foil of all the symbols of love and fertility, his parents become a 'dream couple' – distant and unapproachable, timeless and ageless. The painted dream-like character is confirmed by the 'quotations' cited in the picture. Though the couple echo the gallant pair in Dürer's popular engraving *The Stroll* almost literally in their elegance and pose, Rubens replaces the

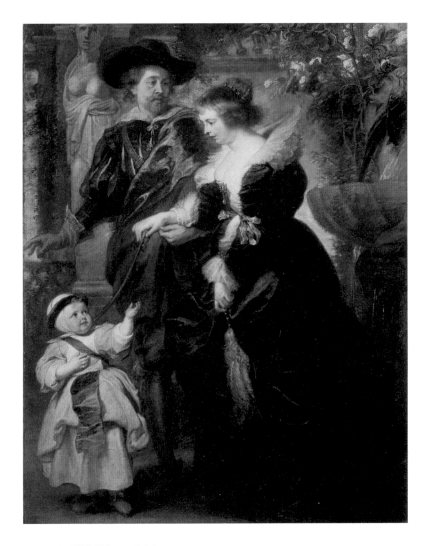

Rubens, his Wife Hélène and their
Son Peter Paul, 1639/40
Oil on panel, 204×158 cm
The Metropolitan Museum of Art,
New York

maliciously lurking figure of Death with life-giving water, flowers and a parrot. The parrot in combination with the luxuriant roses behind Hélène might be more than just another reference to the Virgin and maternity, in fact a literary allusion. In the XVIth canto of Tasso's widely read *Gerusalemme Liberata* (1581), the poet has a gaily coloured bird in Armida's garden sing of love which, like the rose that is plucked early as a half-concealed bud, "perishes before the day is out, the green and blooming flora of mortal life." There could be no finer transfiguration of the painter's belated love for a young budding girl nor a more poetic, sweeter twist to Dürer's graphic *memento mori*. Here as in his alter ago, the young Peter Paul, Rubens banishes death by placing life in its place. But he himself and the initiated among his friends know that this is camouflage and see the melancholy wishful thinking behind the beautiful dream as an all the more poignant *memento mori*.

The beautiful woman, the happy couple, love, the garden – Rubens constantly winnows out new facets of his atmospheric and metaphoric subject matter. A picture that perhaps sums up all the ideas was painted between the two garden pictures. Listed in the inventory of Rubens's estate as *Conversatie à la mode*, it has been known since the eighteenth century as *The Garden of Love*. In this, all the familiar motifs appear poetically intensified. The garden has become a twilit park, Rubens's pavilion a natural temple grotto and, instead of the small well, two figure-adorned fountains provide an excuse for all kinds of merry entertainment for the figures in the scene and much profound head-scratching by posterity.

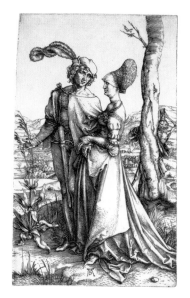

Albrecht Dürer, *The Stroll*, *c.* 1498
Copper-plate engraving,
19.5×12.1 cm

64

Does the carefree, high-spirited scene depict a 'garden party' in the Rubens family circle? Is the assembly of figures borrowed from medieval love gardens a pictorial manual for elegant society based on the many etiquette books of the day? Or is this an allegory of love based on neo-Platonic ideas, and the introduction of a girl to its three phases? And taking this idea a step further, is it Hélène who is undergoing the initiation into love here that, far above low sensuality, takes the form of marriage and heaven on earth, even if it cannot achieve 'heavenly love'? This is a picture full of life, movement and colours which gleam like precious stones; a painting, however, that eludes any clear interpretation. The original title and French fashion allude to the sophisticated behavioural and entertainment forms of a *galant* society that, in accordance with the aristocratic custom of the day, saw the pleasure garden as an alternative model to strict court etiquette. In this Arcadian location, love was celebrated, but the informality was a fiction – only marriage channelled passions and tied emotions down. The vote for marriage is clear enough, what with zealous putti appearing with the marriage yoke above the novice, still shyly hesitant despite a firm shove from Cupid, and the sumptuous peacock tail behind the established couple in marital harmony. The detail of the Junonic feathers sweeping down just beside the 'milk-giving', fecund Venus illustrates Rubens's personal identification of life and marriage, as do the pair of harnessed Venus doves brought on with the marriage yoke. The fact that all the women in the picture resemble Hélène – without any of them constituting a real portrait – says everything about

following double page:
The Garden of Love, c. 1630/33
Oil on canvas, 198×283 cm
Museo Nacional del Prado, Madrid

65

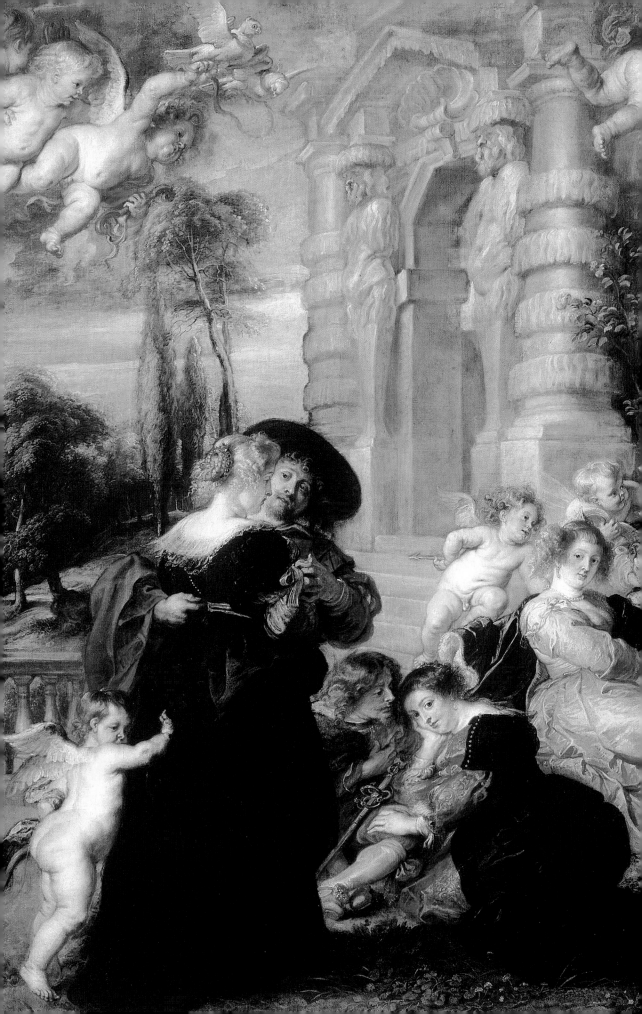

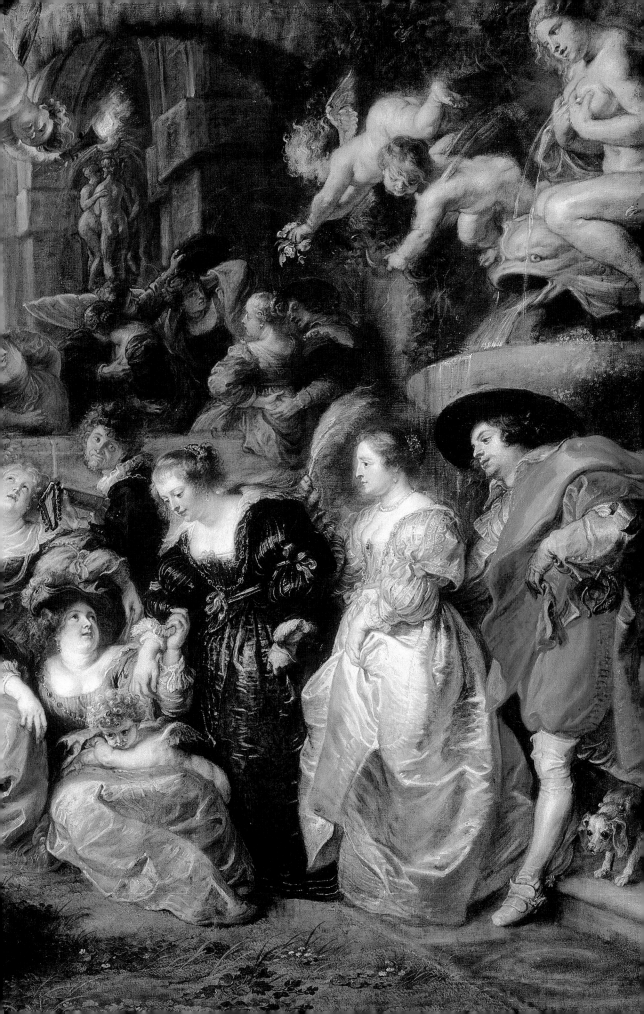

the artist's idealisation of the beloved in Woman. Glorifying *her* and at the same time elevating his neo-Stoic views and his personal bliss into generalisations, Rubens paints his own recent past in the tender wooing and also, in the couple bound in wedded concord and 'doglike' fidelity, in the joyful present. Even the matron leaning over bears Hélène's features – perhaps a glimpse of the future? And she appears once more, young and beautiful in the middle of it all looking out of the picture, as mistress of the garden and the 'graces' that surround her. One might say, as the goddess of love herself.

"Hélène in every woman"

Hélène was present in his œuvre long before she became Rubens's muse as an inspiring model. Blond beauties appear as nymphs and naiads even before 1630 as prefigurations of Hélène, also as an Old Testament heroine, a mythical princess or goddess of antiquity. The lovely Penitent Mary Magdalene and Venus, the fairest of them all, are not only always blond (the latter in accordance with tradition) but light Flemish blond, opulent and rosy – in short, what posterity conceives of as the generic Rubens woman. Although this ideal is not one that found equal approval in every age, Rubens's virtuoso technique for rendering soft flesh and gleaming skin, warm with tangible vitality, has always been admired. It is the painting technique that gives these 'Venuses' the radiance of natural sensuality, the 'eternal woman' who encompasses charm, fertility and seductive innocence. Whereas Rubens's first wife Isabella was the diametric opposite of this type, he found in Hélène the embodiment of the very thing he wanted, as if it had sprung from one of his pictures – Pygmalion's dream come true. It is, therefore, no surprise to find her in many of the late works, more or less 'distanced' as in the *The Garden of Love*, or dressed up in some role or other. The portraits of Isabella are always pictures of a clever, natural woman without affectation painted with the warmth of friendship. That her face appears exalted 'only' in a number of Rubens's Madonnas may be due to the kind of commissions he had at that time and his fascination in the experience of parenthood. Hélène never appears as a

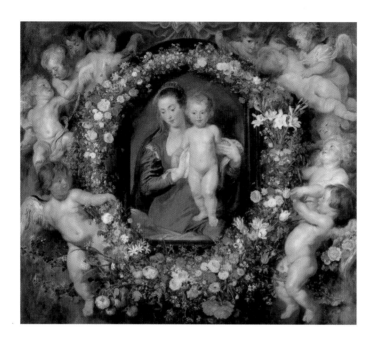

Peter Paul Rubens / Jan Bruegel
the Elder
Madonna and Child in a Garland, c. 1620
Oil on panel, 185 × 209.8 cm
Alte Pinakothek, Munich

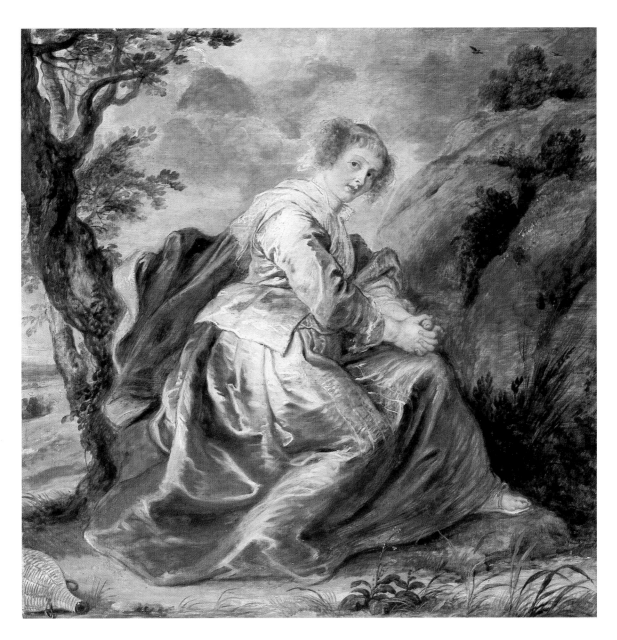

Hagar in the Desert, c. 1635
Oil on panel, 72.6×73.2 cm
Dulwich Picture Gallery, London

Madonna. Even in his *sacra conversazione* for his tomb in the Antwerp church of St Jacob, the tender, spiritually moving Virgin is still a distant reminiscence of Isabella. And though the compositions of Hélène with Frans and *Hélène Fourment and her Children* formally exploit the Madonna model, unlike Isabella, whose features Rubens subsumes fully into the Madonna role, Hélène remains unmistakably herself – the Madonna qualities are attributes and a loving apotheosis of the person portrayed.

It is less the mother role or the internally differentiated character that inspired Rubens in Hélène. But otherwise he really does see and find Hélène "in every woman," and what Goethe's Mephisto holds out mockingly to the (love)sick Faust becomes the heraldic device of some of his finest paintings.

Hélène rarely appears in a religious role. The pose puts the portrait as *Hagar in the Desert* in chronological proximity with *Hélène with her Eldest Son Frans*. But what is a harmonious fusion of Madonna and motherhood – or the ideal and reality – in the latter, is not convincing in the picture of the maid and mother of his son Ishmael that Abraham banishes. Neither the desert nor Helen look particularly lonely and abandoned. The highly contrived scene is interesting principally as a forerunner of French pastoral pictures or English rococo portraits with a landscape background. For all the frothy sketchiness, there remains something colourless, and one can easily imagine how uncomfortable Hélène felt in the ungrateful role of the rejected 'second wife'. The only strange thing is that Rubens, of his own accord, had Hélène pose for the thorny subject in her position as second wife. Did he

take pleasure in conjuring up a blatant counter-image of
a happy remarriage and with a jolly twinkle of the eye
send his beloved wife fictionally into the desert? At any
rate, the scene shows that, though Hélène knew how to
put a brave face on a bad joke, her acting talent and
repertoire of roles were rather limited.

That also applied to roles of a wildly Dionysian
nature. Her figure in *The Feast of Venus* is a striking case.
She could not or did not want to shine as a victim of a
lascivious satyr for all her natural sensuality and, though
her half-hearted reluctance indicates tacit consent, her
amused but strained, 'portrait look', set among bucolic
frolicking, jars nevertheless. This different style is, how-
ever, not a lapse but intention. And not that Rubens was
trying to create a vague link between the remote Classical
period and the present by adding, at a later stage, the
left half of the painting. Instead, it had more to do with
adding a personal touch – perhaps as an illustration of
a newly revived 'satyrical' lust (for life) he himself was
experiencing. In that case, the marginal episode would
be a triumphant counterblast to a racy piece based on
Ariosto dating from 1626–30. In *The Hermit and the Sleep-
ing Angelica*, the hermit can "gape long and tenderly on
his knees at all the charms that captivated his senses"
only with the help of a magic drink that knocks the girl
out, "…yet when he pressed his mouth upon hers / His
own magic turned against him," and shortly before get-
ting to the point the greybeard falls asleep. What is
made the most of here as a vivid contrast; the invitingly
abandoned body of a young woman gleaming like a
shell, so close and yet so unattainable to the old man

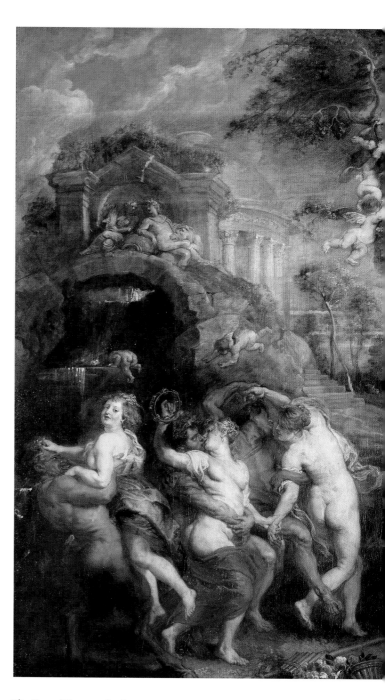

The Feast of Venus, c. 1630/31
Oil on canvas, 217×350 cm
Kunsthistorisches Museum, Vienna

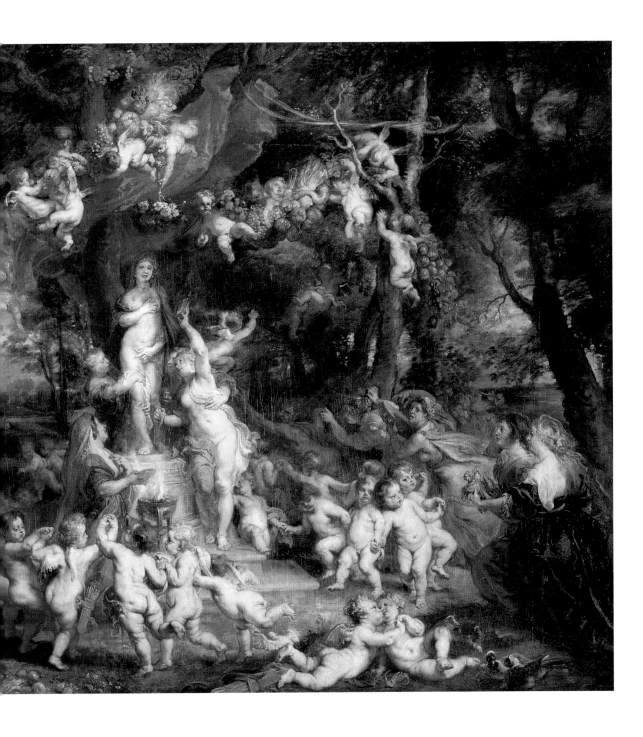

frozen rigid in awe and desire at the same time, becomes downright tangible reality to the satyr in *The Feast of Venus*. The old subject of the unequal couple has a happy ending and becomes a witty *aperçu* with an autobiographical background. Even the deities hovering over the couple, Hercules and Ceres (strength and fertility), have been interpreted as the arms of alliance, since Hercules's attribute, the lion, was part of the Rubens coat-of-arms after he was knighted, as was a sheaf of corn in the Fourment arms.

Hélène is rarely as clearly identifiable as here. Time and again she can be found in the tumultuous crowds of figures in mythological, celebratory and Bacchanalian scenes that Rubens was now painting, but apart from a subsidiary role in the background of the *The Rape of the Sabines*, it is only facets of her beauty that crop up here and there. Whether hesitantly accepting the man's invitation in *The Garden of Love* or as a resisting Sabine woman, willingly seduced or abducted by force, the protagonist is always Hélène – and yet a different one. This also applies to her roles as a grace and as Andromeda, as a nymph, Venus or St Barbara. They are her shapes, but not her features; they have her hair, but not her hairdo, her cheerful radiance but not her tender seriousness.

Where genre scenes and dramatic history paintings offer Rubens an opportunity to depict female beauty, after 1635 he was particularly obsessed with the idea of comparing beauties. He thus transforms the classical sculptural group of *The Three Graces* into flesh and blood and places them against a landscape that looks as Flemish as the curvy shapes of the women. The traditional

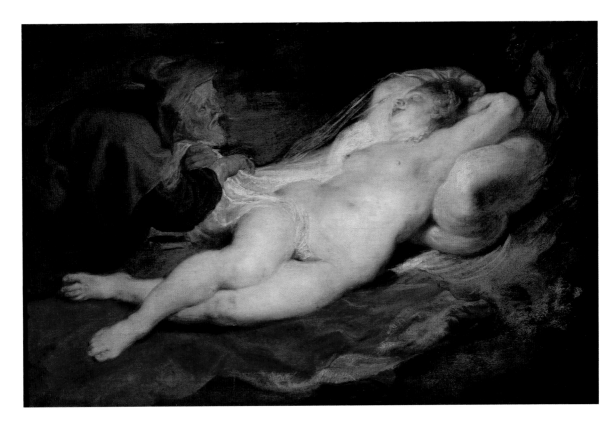

The Hermit and the Sleeping Angelica,
c. 1635
Oil on panel, 43×66 cm
Kunsthistorisches Museum, Vienna

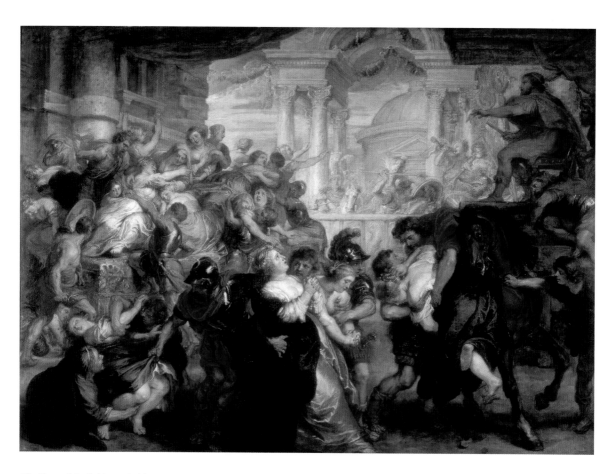

The Rape of the Sabines, 1636/37
Oil on panel, 170×236 cm
The National Gallery, London

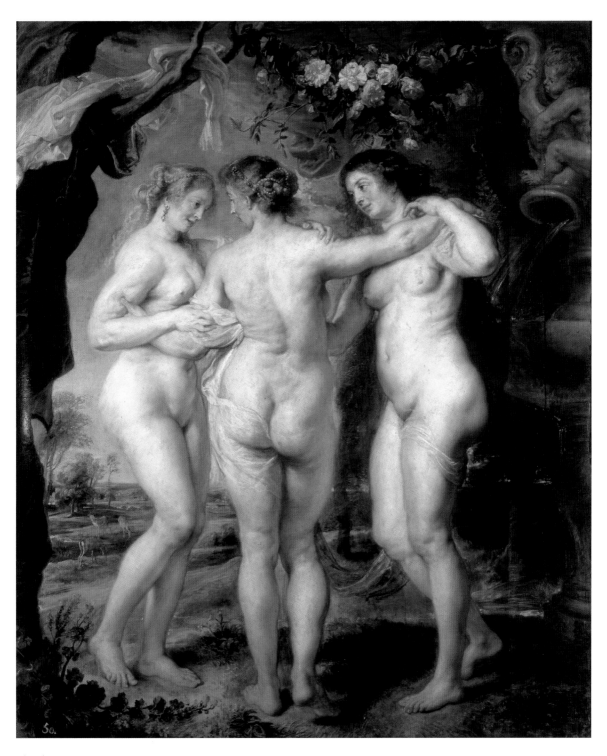

The Three Graces, 1636/38
Oil on panel, 221×181 cm
Museo Nacional del Prado, Madrid

import of the triad is marginalized. Though the vigorous figures are individually scarcely recognisable as the neo-Platonic personifications of beauty, chastity and love, their debt to the classical notion of giving, receiving and giving back are hinted at. Basically however it is all about lovely nakedness. What was merely an attribute of the classical prototype here becomes the main motif. Thus the sole piece of clothing, a gown draped over a branch painted with almost amusing precision in the dangling sleeve, indicates that the delightful process of undressing preceded the scene – an action that rather reveals the nude as a somewhat mortal 'goddess'. It is 'Hélène' that bares all and, still rather shy, has joined the amiable duo. She is the welcome third in the alliance which her arrival makes into a gracious roundelay, and she is, as a bright silhouette against the brilliant cobalt of the sky, undoubtedly the most beautiful. It is Rubens's loving male gaze that distributes the prizes among the per se divine graces of equal rank and, as the gallant director of the scene, elects his wife as the *prima inter pares*.

In this scene he appointed himself to the role of Paris. In another painting, he produced a classic version of *The Judgment of Paris*. Here again, in this archetypal scene of misjudgement, three acknowledged beauties come face to face, only with rather less harmony than with the Graces. In a version of around 1600, Rubens chose to paint the most conflict-charged moment of the competition, the handing of the apple to Venus, drama-tising Juno's overt fury as she is passed over. In the two late works, Paris still has to make a decision, in other words the three goddesses are doing their best to please

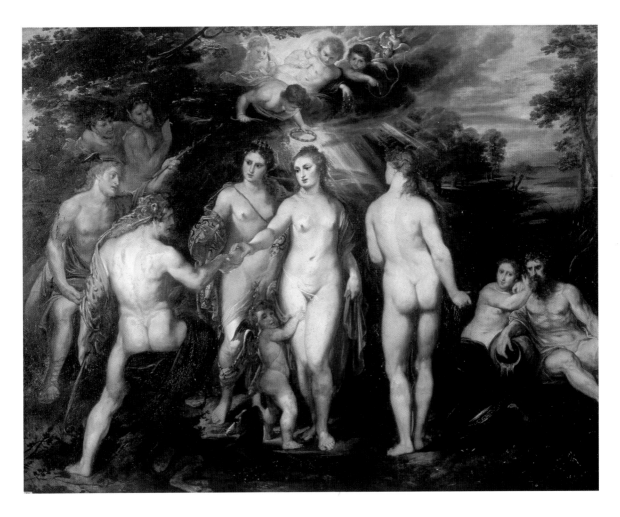

The Judgment of Paris, c. 1600
Oil on panel, 133.9×174.5 cm
The National Gallery, London

him – a scenario men can mostly only dream of. That the latter was his original intention is evident from underpaintings in the London version, which, wholly in accordance with Lucianus, originally stressed the undressing still more. Even in the final version, the veiling and unveiling is delightful enough, but most delightful is the coy *pudica* gesture of the middle candidate, whose winning smile anticipates victory. Hélène the Grace has become Hélène Venus, in a similar profile, where the focus is now on her back, and her skin and outline stand out sharply against the enveloping mantle. It is no wonder that the cool judge of 1600 has become the bewitched, lusting man who has eyes only for one woman – like Rubens himself, obviously his own 'fair Hélène'.

Rubens was not averse to revealing Hélène's entire beauty to the eyes of others. In *The Judgment of Paris* of 1638/39 ordered by Philip IV of Spain, probably a subject suggested by Rubens himself, a painting that he completed with his last strength amid increasingly violent attacks of gout, Hélène is painted almost life-size, the only one of the three women shown frontally in full. "The Venus standing in the middle is a very like picture of his wife, who is undoubtedly the most beautiful woman you can find here," wrote the king's brother, who was at that time in the Netherlands as the Spanish governor. "It is undoubtedly the best picture Rubens ever painted," he continued, conceding that "the goddesses are too naked; but it would be impossible to get the painter to change that, because he insists that it was indispensable for bringing out the painting's value."

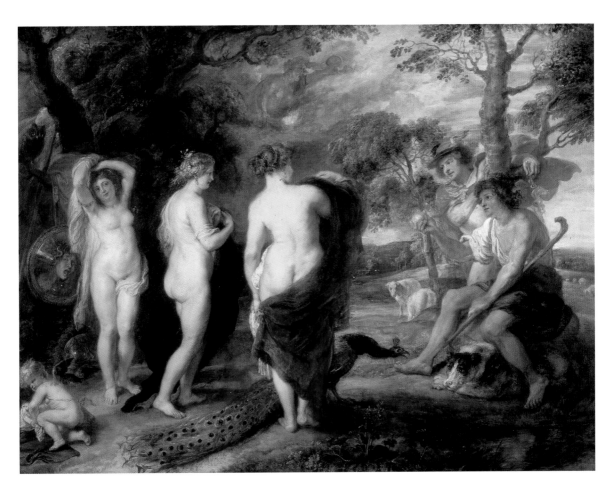

The Judgment of Paris, c. 1635/38
Oil on panel, 144.8×193.7 cm
The National Gallery, London

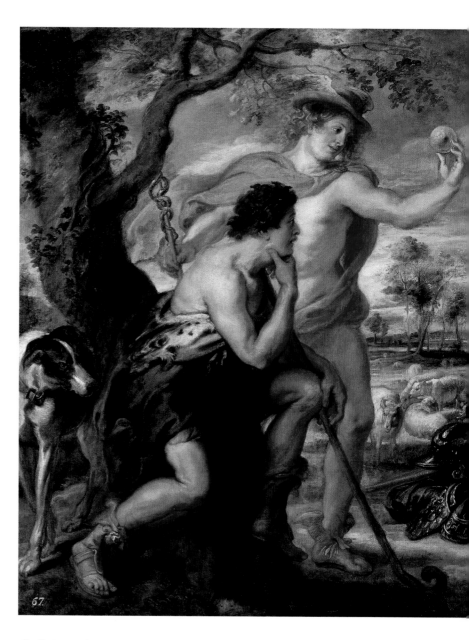

*The Judgment of Paris, c.*1639
Oil on panel, 199×379 cm
Museo Nacional del Prado, Madrid

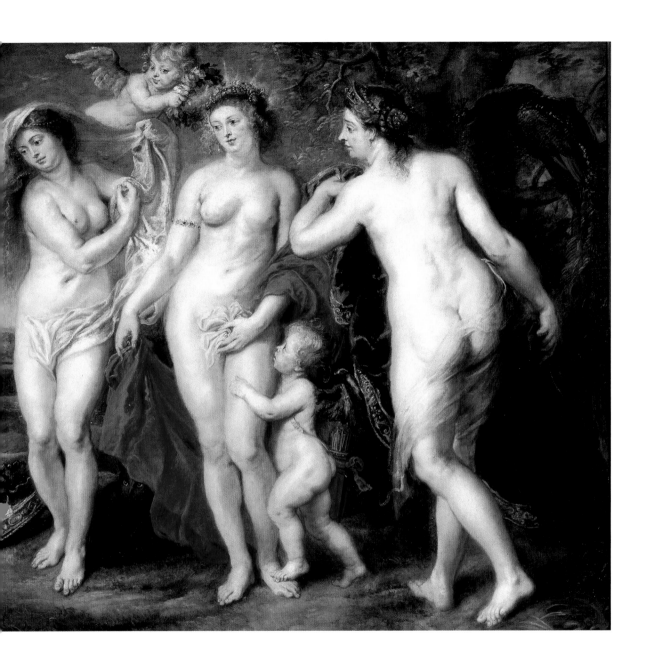

What is this 'value' for the sake of which Rubens was willing to flout convention? It certainly cannot have been to give a faithful rendering of the Lucianus text or show off his own ability as a painter of nudes. Is he a latter-day Candaules, showing off the naked comeliness of his wife? Herodotus describes how the greybeard king of Lydia hid Gyges in his bedchamber so as to reveal the hidden beauties of his young wife, sublimating his own sexual impotence in the boastful pride of possession. The exhibitionism of the one and voyeurism of the other make the woman a trophy of prestige and lust. One cannot absolve Rubens of possessive pride. What he confided to de Peiresc in 1634 – "I would find it difficult to swap the precious treasure of freedom for the caresses of an old woman" – resonates, *ex positivo*, triumphantly in all pictures of Hélène. Rubens wallows in her sensual, youthful beauty with almost childish rapture and constantly re-stages it, dressing it up in new guises. Hélène seems to arouse even his pleasure in the refinements of Eros in ever new ways – see the implicit motif of undressing in the mythological *galanteries*. But the withdrawal of the motif in the London version and absence thereof in the Madrid *Judgment of Paris* show, in the end, that stimuli of this kind were not what it was about. It was much more his comprehensive understanding of 'beauty', which he considered came across better in the form of nakedness than in an erotically charged 'cloaked' form. As Rubens showed in picture after picture, beauty was for him far more than an aesthetic quality. Time and again, Venus appears in his mythologies and allegories as a force to be taken wholly positively, as the quintes-

sence of love, joy, fertility and creative delight. Choosing *her* was for both Rubens and Paris to opt for affirmative life values – in the midst of war-torn times – and it is not for nothing that all the negative omens otherwise going on in the background are absent from the Madrid *Judgment of Paris*. Rubens sees the subject here most definitely not as history but as a parable of one person's idea of bliss (namely his own). And in this case Venus/Helen/Hélène occupies the central role as the radiant source of all good things in divine perfection. Thus the picture for the Spanish king is also the artist's personal avowal and legacy to posterity. The last two pictures of Hélène by Rubens also have the character of a legacy. *St Cecilia* and the picture he himself called the 'Little Fur' (*The Fur*) remained in the house until his death, the latter expressly as an additional bequest to Hélène. Both are role portraits, but from contrary spheres and in very different graduations. What could have induced him to paint Hélène as the patron saint of music, with tear-stained, upturned face, raptly listening? Sublime architecture and sympathising putti contrast with the discarded slipper, the glowing halo around Cecilia's head contrasts with Hélène's heavily reddened cheeks – 'sacred' pathos and, for all the pious ecstasy, homely profane beauty merge into the image of what might once have been called a 'beautiful soul'. The latter is stirred by music, whose rich chromatics are reflected in the coruscating colours, 'tones' that are reminiscent of the delicate portrait of *Hélène with her Eldest Son Frans*. For all its assured virtuosity, the picture was painted in haste, as if Rubens wanted to record a facet of the beloved wife once again and,

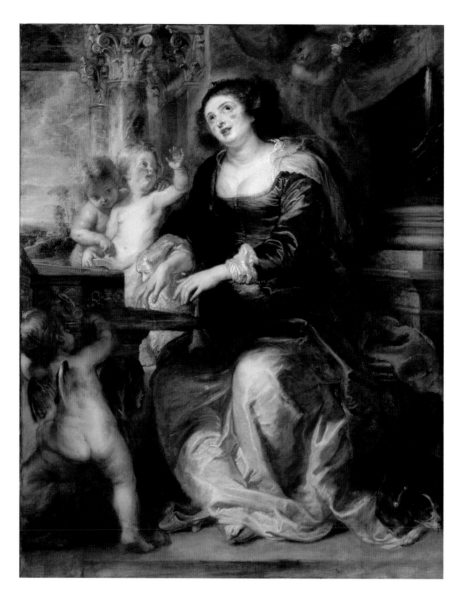

St Cecilia, *c.* 1639/40
Oil on panel, 177×139 cm
Gemäldegalerie, Berlin

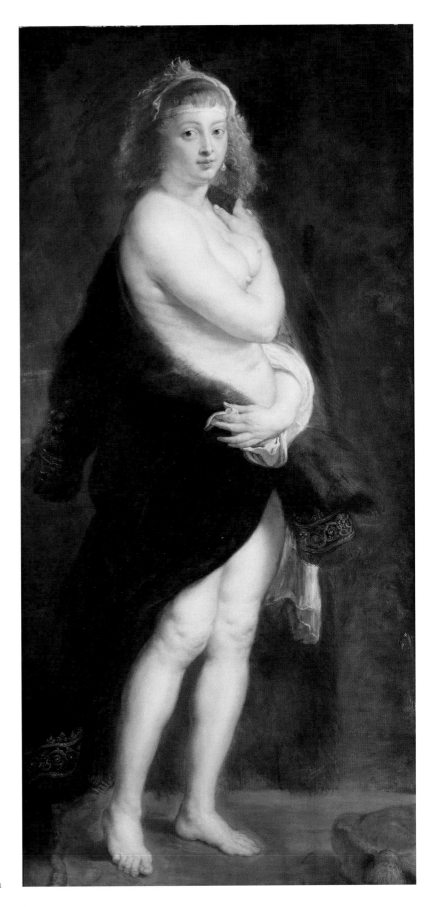

The Fur (Het Pelzken), *c.* 1638
Oil on panel, 175×96 cm
Kunsthistorisches Museum, Vienna

with similar enthusiastic verve, exalt it in the shape
of the inspired saint, just as much as firmly placing it
in reality through the accuracy of its charmingly sweet
detailing.

A second look at *The Fur* reveals it as real idolisation
of its subject. It was provocative in its day and undoubt-
edly daring even for posterity, at least if exhibited to
the public gaze, which was never its purpose. The figure
is in itself less exposed to the viewer than the Venus of
The Judgment of Paris or the contemporary *Andromeda*.
However, the quality of the nakedness is something else
again. Hélène appears without any kind of idealisation.
Rubens reproduces the folds and irregularities of a
mature female body – *his* wife – in warm light and with
warmth. The almost tangible portrait character of the
body is what is daring. It also jars with the models that
inspired it, Titian's cool, elegant *Woman in a Fur Coat* and
the classical Venus Pudica, and at the same time brings
them back to life in a new way. Placing the nude in an
inner courtyard with a fountain, combined with the fur
wrapped protectively around her, suggests a before or
after the bath situation which was a favourite erotic sub-
ject of the time, disguised in the moral cloak of Susannah
being secretly spied on by the elders. However, there is
no expression of surprise or even alarm and perturbation
in *The Fur*. It is the same look Hélène had in her 'bridal'
dress or in the picture with son Frans – at once serious
and full of joy, loving and beguiling and full of promise.
And, once again, it is solely addressed to the painter.
For *his* eyes, the protective *pudica* gesture suggestively
changes into one of tender allure, anticipating a loving

Titian, *Woman in a Fur Coat, c.*1535
Oil on canvas, 63×95 cm
Kunsthistorisches Museum, Vienna

embrace. There is also tenderness in Rubens's description of the picture as *Het Pelsken*. It was perhaps one of those memorable intimate marital moments, the couple's personal code to posterity to unravel the coquettish, anecdotal title, given to a work in which Rubens's art, his love of life and his love of Hélène were blended in equal measure.

Further Reading

D. Bodart, *Rubens*, Milan 1981

J. Bouchot-Saupique, *Hélène Fourment. Rubens*, Paris 1947

C. Brown, *Making and Meaning: Rubens's Landscapes*,
New Haven 1996

L. Burchard and R.-A. d'Hulst, *Rubens: Drawings*
(2 vols.), Brussels 1963

K. Downes, *Rubens*, London 1980

T.-L. Glen, *Rubens and the Counter-Reformation:
Studies in his Religious Paintings, between 1609 and 1620*,
New York 1977

C. Goettler et al, *Rubens and His Ages: Treasures from the
Hermitage Museum*, London and New York 2001

E. C. Goodman, *Rubens: The Garden of Love as 'Conversatie
à la mode'*, Amsterdam/Philadelphia 1992

J. S. Held, *The Oil Sketches of Peter Paul. Rubens:
A Critical Catalogue* (2 vols.), Princeton 1980

J. S. Held, *Rubens and his Circle*, Princeton 1982

M. Jaffé, *Rubens and Italy*, Oxford 1977

M. Jaffé, *Ripeness is All: Rubens and Helene Fourment*,
in Apollo, 1978

R. Klessmann, *Rubens' Saint Cecilia in the Berlin Gallery
After Cleaning*, in Burlington Magazine, cvii, 1965

W. A. Liedtke, *Flemish Paintings in the Metropolitan Museum
of Art*, New York 1984

J. R. Martin, *Rubens: The Antwerp Altarpieces, The Raising
of the Cross / The Descent from the Cross*, New York 1969

E. Michel, Rubens: *His Life, His Work and His Times*
(trans. E. Lee), London and New York 1899

L. van Puyvelde, *Les portraits des femmes de Rubens*,
Paris 1937

*Peter Paul Rubens: A Touch of Brilliance, Oil Sketeches and
Related Works from The State Hermitage Museum and
the Courtauld Institute Gallery* (exhib. cat.),
Munich/Berlin/London/New York 2003

C. Scribner III, *Rubens*, New York 1989

W. Stechow, *Rubens and the Classical Tradition*,
Cambridge, MA 1968

L. Vergara, Rubens and the Poetics of Landscape,
New Haven and London 1982

C. White, *Peter Paul Rubens: Man and Artist*, New Haven
and London 1987

J. Wood, *Rubens: Drawing on Italy*, Edinburgh 2003

Photographic Credits

Pictorial material has been kindly provided by the museums and collectors mentioned in the picture captions or taken from the Publisher's archives, with the exception of the following:

The chapters *Metamorphosis* to *Ideal reality*, incl. were written by
Markus Kersting, "*The loveliest woman you will find here ...*" – *Hélène in
portraits* to "*Hélène in every woman*" by Dagmar Feghelm.

Front cover and inside front flap: *The Three Graces* (detail), see p. 79
Spine: *The Fur (Het Pelzken)* (detail), see p. 85
Back cover: *The Garden of Love* (detail), see pp. 66/67
Frontispiece: *Self-Portrait,* see p. 23

© Prestel Verlag, Munich · Berlin · London · New York, 2005

The Library of Congress Cataloguing-in-Publication data is available;
British Library Cataloguing-in-Publication Data: a catalogue record for
this book is available from the British Library; Deutsche Bibliothek
holds a record of this publication in the Deutsche Nationalbibliografie;
detailed bibliographical data can be found under: http://dnb.ddb.de

Prestel Verlag
Königinstrasse 9, 80539 Munich
Tel. +49 (89) 38 17 09-0; Fax +49 (89) 38 17 09-35

Prestel Publishing Ltd.
4 Bloomsbury Place, London WC1A 2QA
Tel. +44 (020) 7323-5004; Fax +44 (020) 7636-8004

Prestel Publishing
900 Broadway, Suite 603, New York, NY 10003
Tel. +1 (212) 995-2720; Fax +1 (212) 995-2733

www.prestel.com

Translated from the German by Paul Aston
Copy-edited by Christopher Wynne

Design and production: Matthias Hauer
Typefaces: *Berthold Baskerville* and *Linotype Syntax*
Originations: Reproline Mediateam, Munich
Printing: Appl, Wemding
Binding: Oldenbourg, Monheim

Printed in Germany on acid-free paper

ISBN 3-7913-3316-x